LOST MANSIONS OF MISSISSIPPI

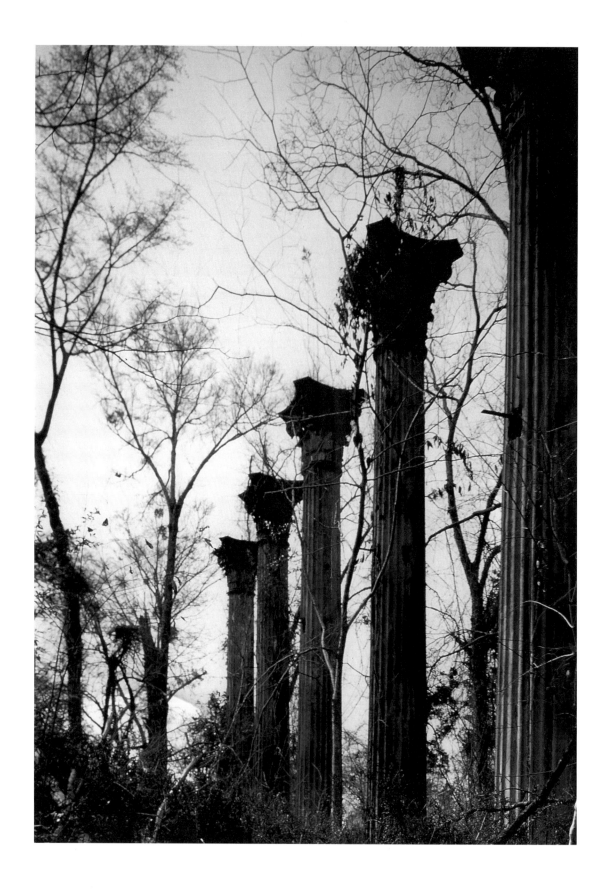

Lost Mansions of Mississippi

MARY CAROL MILLER

University Press of Mississippi Jackson

Copyright © 1996 by the University Press of Mississippi

All rights reserved

Manufactured in the United States of America

99 98 97 4 3 2

The paper in this book meets the guidelines for permanence
and durability of the Committee on Production Guidelines
for Book Longevity of the Council on Library Resources.

Library of Congress Cataloging–in–Publication Data

Miller, Mary Carol.

 Lost mansions of Mississippi / Mary Carol Miller.

 p. cm.

 Includes bibliographical references and index.

 ISBN 0–87805–888–5 (cloth : alk. paper)

 1. Architecture, Domestic—Mississippi. 2. Lost architec-
ture—Mississippi. I. Title.

NA7235.M7M55 1996

728.8'09762—dc20 95–51855

 CIP

British Library Cataloging-in-Publication data available

This book is dedicated to my parents,
RUSSELL AND SARA CRISS,
who chose to raise their children as Mississippians
and to my own children,
EMILY AND JIM,
who will, I hope, make the same choice

ॐ

CONTENTS

PREFACE

In the depths of America's Great Depression, unemployed writers were engaged by the Works Progress Administration to compile travel guides for each state. *Mississippi: The WPA Guide to the Magnolia State* was originally published in 1938 and reprinted by University Press of Mississippi fifty years later. Like a mirror reflecting a half-century's change in the state, it is a fascinating collection of people, places and traditions. Most significantly for those interested in the architecture of the Old South, the WPA writers described in considerable detail dozens of antebellum mansions, often in the last days of their existence. Except for the WPA documentation, many of these houses would now be altogether lost memories. Equally fortuitous for posterity was the initiation of the Historic American Buildings Survey (HABS), a New Deal project intended to provide employment for architects and photographers. Armed with their cameras, these talented professionals roamed across Mississippi, taking starkly dramatic black-and-white photos of the state's landmark houses, some in pristine condition, others merely desolate shells. Now collected in the Library of Congress, the HABS pictures are the last and, in many cases, the *only* known graphic documentation of these now-vanished structures.

When I first looked through the *WPA Guide* in 1988, I was amazed at the sheer number of mansions described there and evidently destroyed in the fifty years since 1938. Like most Mississippians who enjoy the spring ritual of pilgrimage tours, I had assumed that the columns of Windsor represented the exception rather than the rule; surely the best of Natchez and Woodville, Columbus and Holly Springs had survived to symbolize Mississippi's architectural golden age. The sad truth lay in the files of the historic preservation division at the Mississippi Department of Archives and History (MDAH). For every stately mansion carefully restored and maintained, many more had disappeared, victims of fire, weather and economic decline.

This collection of photos, drawings and histories includes fifty-six of these lost antebellum treasures. They were chosen from a much longer list based on their architectural significance, their connection with a notable figure in Mississippi history or a combination of both criteria. Some were truly mansions; others were simple cottages constructed by itinerant frontier carpenters. Many were the homes of governors, generals or cotton barons, names known to every student of Mississippi history, while

others sheltered families whose time in Mississippi passed in a generation or two. Whenever possible, I talked with descendants of the original owners of the houses, and they were unfailingly generous with family photos and folklore. More difficult was detailing those homes lost a century or more ago, their families long since scattered and perhaps now unaware that their ancestors contributed to a unique chapter in American architecture.

I have chosen to arrange the chapters according to the geographic locations of the houses rather than by their styles. The oldest sections of the state, such as Natchez and the Gulf Coast, show a progression of styles ranging from the early provincial French influence through the Federal period and Greek Revival. Areas that developed later in the nineteenth century feature predominately Greek Revival and the subsequent Italianate detailing, along with a few Gothic Revival examples. The number of houses included in each chapter does not so much reflect the concentration of fine structures in a particular region as the extent of loss in that community. Columbus, for example, receives scant attention here simply because it has, fortunately, suffered the loss of only a few of its truly significant antebellum structures. Holly Springs, by contrast, is extensively covered because of its regrettably large number of vanished homes. Simple constraints of time and available material prevent the inclusion of a few areas with a strong antebellum tradition, such as Macon, Enterprise, Lexington and the southwest Mississippi area around Brookhaven and Monticello. Communities such as Hattiesburg, Meridian and Laurel are also absent, their architectural heritage being more representative of the Victorian period than the pre-1865 styles detailed in this volume.

The WPA guide included detailed directions to each house; unfortunately, these are often now obsolete, highways having been renumbered and landmarks long gone. Terrain which once held landscaped gardens and plowed fields may have reverted to forested wilderness. While some locations, particularly those within existing communities, can be pinpointed exactly, other sites are remembered only in the vaguest terms. Those intrigued enough to search for homesites would do well to contact the local historical society for directions and advice on accessibility.

The historical background material on each house was taken from sources at the Mississippi Department of Archives and History, local historical societies and family lore. The *WPA Guide to the Magnolia State* was an invaluable reservoir of local tradition, much of it gained firsthand in the 1930s from elderly Mississippians who remembered these houses in their finest days. Photos came from the HABS collection at the Library of Congress, the MDAH files, regional library files and private collections. In researching these houses, I found reference to many other homes; some are not included here because diligent searching turned up only a name and nothing else. For the purposes of completeness, I have listed every "lost" antebellum house that I am aware of in the appendix. Their stories need to be told, too; perhaps this volume will prompt a few attic searches or jog some old memories.

INTRODUCTION

The years 1830 to 1860—three short decades—saw the rise of most of Mississippi's antebellum mansions, with their increasingly grand facades and columns, porticoes and cupolas. For those few brief years, Mississippi was America's land of dreams, a barely tamed frontier where fortunes were being made overnight. Here, the nation's architectural infancy burst forth in an exuberant display of structural one-upmanship, each new house just a bit showier than its neighbor. Mississippi's turn at the top would be short-lived, the prosperity and preeminence disappearing as quickly as they came, victims of civil war. The great houses were left like dusty time capsules from a never-to-be-repeated era.

Statehood came in 1817, just ahead of America's shift away from long-established European building traditions. Most dwellings in the new state's backwoods and tiny communities were crude dogtrots and log cabins, but a few notable houses were already standing in the old settlements along the Mississippi River and the Gulf Coast. Concord and the Pirate House (both nonextant) were built around 1800, their frame structures raised over full brick basements in a design seen throughout the West Indies and areas along the Gulf of Mexico. Natchez was well into a decade of Federal styling, already boasting such enduring landmarks as Auburn (1812) and Rosalie (1822). Their fanlighted doorways, rigid symmetry and imposing columned porticoes were portents of the astonishing building boom yet to come.

By 1830, a series of treaties with the Choctaw and Chickasaw Indian tribes had opened up millions of acres of Mississippi land for development. Over the next twenty years, thousands of farmers and speculators would leave the worn-out dirt of the Carolinas, Georgia and Tennessee, and pour into the heartlands of Mississippi to claim their share of the promise. The rich soil seemed to produce cotton like magic, white gold to fuel the exploding economy of the young state. As fortunes were made and towns sprang up along the rivers and railroads, this new class of pioneer aristocrats wanted fine houses to reflect their wealth and success.

As Mississippi was establishing itself, America was watching with sympathy the struggle for Greek independence and reading with fascination stories of Greek and Roman archeological discoveries. For a nation that saw itself as the repository of ancient democratic ideals, the temples and columns of the Old World seemed to best

represent that legacy. Greek Revival styling captured builders' imaginations throughout the United States; first utilized for public buildings, churches and banks, it gradually came to be the favored choice for homes, also. Mississippi's tenure as the ultimate province of King Cotton overlapped this mania for Greek design, and the race was on to build town houses and plantation homes that would rival those being constructed in the older areas of the country. Full-height entry porches capped with pediments or entablatures, stuccoed or wood columns topped with classical capitals, and elaborate doorways framed with sidelights and transoms were the hallmarks of true Greek Revival styling, and these details became increasingly elaborate and ornamental as the state's architectural sophistication blossomed.

The Greek Revival style, which will forever be emotionally linked with the Old South, was popular not only for its beauty but also for its utility. The high-ceilinged rooms and wide porches lent themselves to the torrid climate of the region, and the solidity and outright ostentation of the temple form fit the planters' self-image nicely. As the state's most well-established and prosperous community, Natchez led the way in Greek Revival architecture, its standards climbing steadily higher to peak in such homes as Stanton Hall (1858), D'Evereaux (1840) and Dunleith (1857). Newer towns were not overshadowed by Natchez for long, however; Columbus, Aberdeen and Holly Springs were growing rapidly in the old Indian territories, and their citizens seemed determined to match the nabobs of Natchez brick for brick. In small towns scarcely established enough to have a courthouse and a few muddy streets, mansions like Columbus's Riverview (1852) and Aberdeen's Magnolias (1850) were going up, as often as not without the benefit of a trained architect's guidance. Self-taught carpenters followed the patterns in books such as Minard Lafever's *The Beauties of Modern Architecture* and Asher Benjamin's *The Builder's Guide*.

Surviving examples indicate that Greek Revival deserves its reputation as the symbol of antebellum Mississippi, but the Italianate and Gothic Revival styles also enjoyed widespread popularity during the 1850s. The bracketed eaves, tall arched windows and square towers of Italianate designs were sometimes blended with Greek Revival facades. Only a few pure Italianate houses were ever built in Mississippi; these included Mannsdale's Annandale (1857) and Ingleside (1854) and Washington County's Mount Holly (1859). Gothic Revival's steeply pitched rooflines, carved vergeboards and flattened arches were more difficult to execute; consequently, true Gothic Revival houses were even rarer than Italianate. In Holly Springs, Cedarhurst and Airliewood (both late 1850s) were unusually true to the design books from which they were drawn. Malmaison (1854) and Prairiemont (early 1850s), both in Carroll County, were skillful blends of Greek Revival and Italianate features, and Aberdeen's Greek Revival Herndon-Spratt House (1844) included pointed Gothic arches in its windows and masonry. Columbus builders, developing an altogether unique style that would come to be known as Columbus Eclectic, combined elements of all three prevailing fashions in a manner seen nowhere else in the country.

Mississippi's building frenzy peaked along with the cotton-based economy in the

late 1850s, a time when imposing mansions were under construction throughout the state. Carpenters and brickmasons were at such a premium that many builders imported workers from New England and the Atlantic seaboard states. Others trained slaves to fashion bricks; court papers in Adams County suggest that female slaves may have been given the responsibility of molding the triangular bricks used in the stuccoed columns of the Forest (1816). Racing to complete showplaces like Stanton Hall and Longwood in Natchez, LaGrange near Woodville and Windsor in Claiborne County, the owners and architects were battling not only the usual contractual deadlines but also the mushrooming rumors of war. When that war finally came, it would leave this land of memorable mansions devastated and bereft of money, manpower and hope. The most poignant examples of the Civil War's death knell for architecture are the dusty tools still lying in the echoing shell of Longwood, hammers and wrenches having been dropped by northern workmen fleeing in the wake of Fort Sumter's cannons. But Longwood wasn't the only dream dashed in the chaos that followed: Marshall County's Morro Castle stood for three-quarters of a century as a pathetic, half-roofed shadow of its intended magnificence, and somewhere beneath a Claiborne County field lies the foundation of a house intended to be even larger and grander than the fabled Windsor.

Many of Mississippi's most unusual homes have vanished from all but the longest of memories. With rare exceptions, such as Clifton, Bowling Green, and Greenwood, few were actually destroyed by Union soldiers, popular legend notwithstanding. Their real enemy was the state's long economic decline and the stylistic changes that rendered them obsolete. Reconstruction, falling cotton prices, population shifts and the rise of Queen Anne and Neoclassic styles all took their toll on the old houses. Fields that a generation before had seemed limitless in their ability to produce cotton were now eroding rapidly, and planters faced with heating twenty high-ceilinged rooms or painting forty-foot columns often simply turned their backs and walked away, leaving Grandfather's brick-and-mortar legacy to the elements.

A handful of houses survived long-term abandonment and neglect, but many others burned or slowly crumbled beyond the point of salvage. By the 1930s, the status of scores of Mississippi's century-old mansions was precarious and fading fast. A WPA writer riding the road between Red Banks and Memphis described the sad trek: "A great many crumbling mansions, built during the flush times of the 1830s and 1840s, desolately face the encroaching gullies. These houses, gradually mouldering away as the earth slides from beneath them, are unpainted, with sagging porches and rotting pillars."[1] Twenty-five years of desertion had taken its toll even on the indomitable Waverley: "The years have ravished it of life and color. . . . Some of the stained-glass sidelights from Venice on the front entrance are cracked. The thirty-foot hall has a wax-smooth floor and satin-smooth plastered walls, but the gilt-framed mirrors on the white marble consoles are covered with a film of dust, as is the piano with its mother-of-pearl keys. The draperies of the parlor windows are faded and drab as the outside paint. . . . The boxwood hedge is covered with vines. The green shutters are

faded, the garden rank with weeds, and the swimming pool dry. Unoccupied and dilapidated, it is still majestic."[2]

Mississippi's architectural treasures *were* still majestic, even after decades of decline, and their slow salvation began, fittingly enough, in Natchez. Faced with wilted azaleas after a late spring frost in 1931, the garden club ladies of that town were in a panic, because they were expecting hundreds of visitors from around Mississippi for the annual meeting of the State Federation of Garden Clubs. As a last resort, they reluctantly opened the doors of their antebellum homes, and a tradition of pilgrimage hospitality was born. Other towns joined in the bonanza, tourists came from around the nation and the world, and more than one dilapidated mansion was saved from the wrecking ball by an infusion of "Yankee" dollars.

Public awareness of the advantages of historic preservation has now virtually assured the future of Mississippi's mansions. But for every one that stands restored today, several others have vanished forever. In the pages that follow, the fading images of these proud houses are mute testament to a generation of Mississippians who brought a touch of beauty and nobility to a wild frontier. Some houses are well documented, complete with family histories and floorplans; others survive only as scratchy photographs that have been buried unnoticed in attics or archival collections. A few left no visual evidence at all, but the descriptions handed down across the years warrant their inclusion in any collection of memorable Mississippi houses. Each deserves to be remembered as a symbol of those brief decades when Mississippi set the pace for America's architectural excellence.

ACKNOWLEDGMENTS

Many of the houses included in this book have been gone for so long that they have been totally forgotten by all but the most history-minded citizens of their communities. Others are such recent losses that their sites will still yield bricks and nails. In either case, these old homes seem to have tapped a wellspring of civic pride in the towns where I did my research; I never failed to be amazed at the willingness of perfect strangers to share their family histories and heirlooms with me. Local history buffs like Chesley Smith of Holly Springs, David Smith of Woodville, Helen Crawford of Aberdeen and Tommy Covington of Ripley are the kind of people who give the heart and soul to their hometowns. Following is a list of all those who so willingly answered my myriad questions and graciously shared their photos and scrapbooks:

Natchez: Ron Miller, Mimi Miller, Carolyn Vance Smith, Dr. Thomas Gandy, Joan Gandy, David Pruett

Woodville: David Smith, Mary McGehee, Mary Stewart Jones, Alex Ventress

Port Gibson: Al Hollingsworth, Libby Hollingsworth, Linden Magruder, Gene Sulser, Shelley Ferris

Vicksburg: Gordon Cotton, Nancy Bell, Ceress Newell

Hinds/Madison Counties: Dr. Judy Gore Gearhart, Shirley Faucette, Marion Wells, Gay Yerger, John Yerger, Margaret Thompson

North Central: Emily Humphrey, Ruffin Sledge Davis, Dr. Lucius McGehee, Dr. Thomas Hines, Louise Meek, Estess Pleasants, Donna Dye, Dr. William Hamer, Frances Welch, Opal Worthy, Walker Coffey, Herman Taylor, William Lewis

Holly Springs: Chesley Smith, Dr. Hubert McAlexander, May Alice Booker, Vadah Cochran, Hugh H. Rather

Ripley: Tommy Covington

Aberdeen: Helen Crawford, Jerry Harlow, Mrs. Charles Hamilton, Robert Ivy, Jr., Frances Ivy

Columbus: Sam Kaye, Mary Bess Paluzzo, Ken P'Pool

Gulf Coast: Pat Mowery, Charles Gray

Delta: Russell Hall, Winnie Darnell, Clinton Bagley, Mrs. W.C. McKamy, Patricia Cheatham

In addition to this army of amateur historians, I must express my heartfelt thanks

to the staff at the historic preservation division of the Mississippi Department of Archives and History. Ken P'Pool, Richard Cawthon, Todd Sanders, Tomas Blackwell and Brenda Crook are the appointed guardians of Mississippi's architectural heritage, a daunting assignment. Despite their workload, they never failed to bend over backwards helping me with technical questions and searching for rare photos. This book would never have gotten off the ground without them.

Mississippi Magazine editor Ann Becker gave me a chance to put this story together when it only included six houses; I will always be grateful for her willingness to take a chance on an unpublished writer. University Press of Mississippi editor JoAnne Prichard has been unfailingly supportive, taking my vague idea for a book-length treatment and giving it direction and coherence. Her patience and understanding allowed me to work at my own pace, and I believe this is a better book for that lack of time limits. Mimi Miller of Natchez and Todd Sanders at MDAH shared their broad knowledge of historic architecture as they proofread the manuscript; their enthusiasm for this amateur's efforts was immeasurably valuable.

Last, but in no way least, are three exceptional people who provided the encouragement that more than once kept the manuscript, notes and pictures from flying out the window. Cathy Criss Adams is my favorite novelist and a wonderful sister; she was simply born to be a writer and I continue to follow in her footsteps. My dear friend and fellow Delta expatriate, Elizabeth Hamm, has walked a thousand predawn miles with me, and she knows more about book publishing now than any other investment banker in Mississippi. When these old houses start running my life, she's always there to listen and nudge my priorities back into place. And, finally, my husband, Jimmy, refused to let me quit when photos couldn't be found, sources dried up and the words just wouldn't jump onto the paper. He has listened to the stories behind these houses when I'm sure he would much rather have been doing *anything* else, and he has humored me on many a wild goose chase looking for homesites. Thanks for pulling me out of more than one ditch, Jimmy; as usual, you made all the difference.

LOST MANSIONS OF MISSISSIPPI

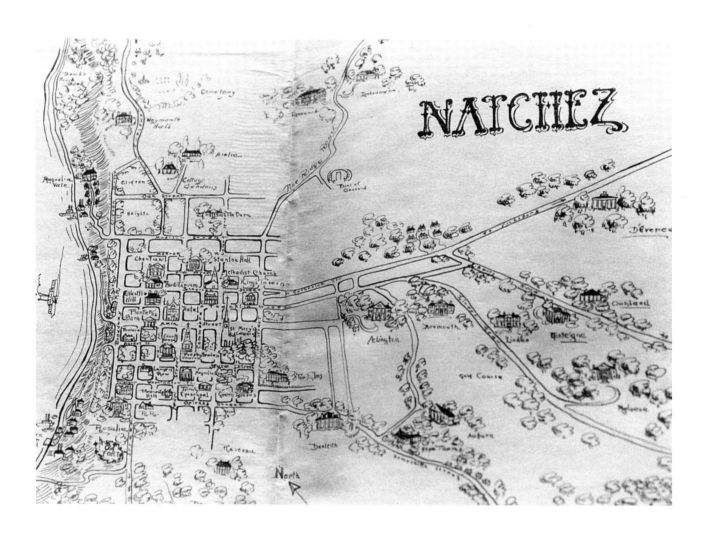

CHAPTER ONE

Natchez

Scattered around Natchez, tucked away on quiet streets or surrounded by modern development, the city's grand antebellum mansions survive to serve as monumental symbols of Mississippi's flush years. Their very existence reflects the confluence of social and economic trends that brought prosperity to this corner of America just as the new nation's architectural infancy burst forth with an exuberance not seen since. Planters and the merchants who grew rich from their patronage competed in a genteel battle of brick and mortar, outdoing each other with ever-more-impressive facades and fanlights, columns and capitals. Although these homes were built for the ages— meant to stand as long as the ancient Greek temples and Italian Renaissance villas they imitated—fire and neglect and changing fashions have taken a sad toll on their number. Now subdivisions cover the foundations of long-forgotten mansions, and kudzu hides the fragments of stuccoed columns and slate porches in the Adams County countryside.

Natchez is the oldest continuous settlement on the lower Mississippi River, and it passed through French, British, and Spanish control over the course of the eighteenth century. Only under Spanish dominion did the area finally establish an architectural presence. When the king's commandant, Don Manuel Gayoso de Lemos, arrived to raise the flag of Spain in 1789, he found a squalid village rambling along and beneath the bluffs of the Mississippi River. Gayoso informed the authorities in New Orleans that a suitable governor's residence was an immediate requirement, and eight thousand dollars was budgeted for its construction. Gayoso oversaw the design of Concord, an imposing three-story blend of West Indian and Gulf Coast building traditions completed in 1794 or 1795.

Following the prevailing manner in which a frame house was elevated over a brick basement level, CONCORD was by far the finest house of Natchez's Spanish Period. Its rooms opened onto broad galleries sheltered by a canted roofline. The primary level included bedrooms, a drawing room, dining hall and formal receiving areas. The ground floor held servant quarters, storerooms and, most likely, space for the horses. A wide carriageway split the rooms in the basement, providing visitors with shelter from the weather. Concord's most memorable feature, its gracefully curved exterior twin stair, was probably added in the 1820s or 1830s, along with the full-height Classical Revival portico and Tuscan columns.

Natchez city map, showing locations of existing and lost mansions. Reproduced from Theodora B. Marshall and Gladys C. Evans, *A Day in Natchez,* 1946.

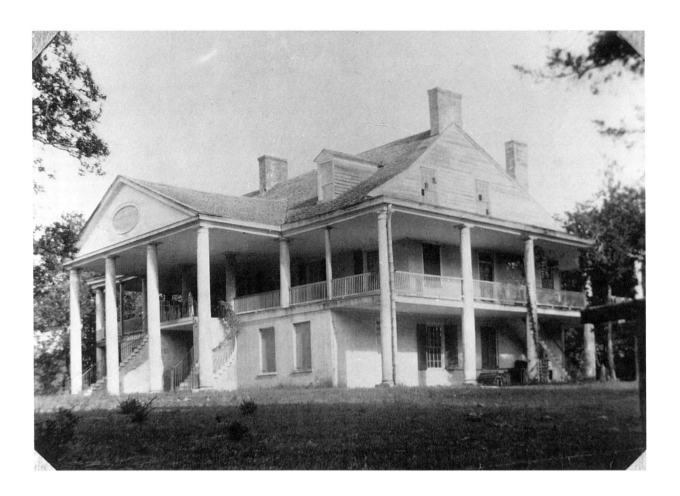

Concord, home of the Spanish provincial governor Manuel Gayoso de Lemos. Photo courtesy of Mississippi Department of Archives and History (MDAH).

Governor Gayoso put his new mansion to good use, establishing it as the center of the hospitality that would become synonymous with Natchez. He was a benevolent administrator, and his cultured British education served him well in this far-flung outpost of the Spanish empire. Spain was encouraging immigration into the Natchez district with liberal land grants and low taxes, and Natchez was starting to grow rapidly. When Gayoso was promoted to governor-general of Louisiana in 1797, his Natchez post was given to Stephen Minor, a Philadelphian rewarded with huge land grants for his service with the Spanish military in its conflict with England. Minor not only assumed Gayoso's job, but also bought Concord from him.

Stephen Minor fit right into the extravagant pace established by Gayoso. In 1797, his nine plantations produced twenty-five hundred bales of cotton, and he ranked as one of Natchez's richest citizens in the first two decades of the 1800s. Shadowy characters and soldiers-of-fortune like James Wilkinson and Philip Nolan were guests at Concord, but Minor was apparently an effective and honest administrator during the area's years of transition from Spanish control to American territorial status. Minor's wife, Catherine Lintot, was a hostess worthy of Concord, decorating the house in bright yellow shades and living on there for many years after Stephen's death in 1815.

Her children and grandchildren bred championship racehorses and sponsored cricket competitions on the vast lawns of Concord. An 1844 political barbeque drew between four and five thousand spectators to hear Seargent S. Prentiss speak, and the Civil War passed with no damage to the old house. Its location several miles inland from the river spared it from the rare shells directed at Natchez.

By 1867, Concord's glory days had passed; the Minor family moved to another of their plantations, and the mansion passed into disuse. For a brief period its huge rooms served as a schoolhouse, and community parties were held there when no other place was large enough to accommodate them. But a lack of occupancy led to continued deterioration of the century-old structure, and it was in sad shape when first seen by George Malin Davis Kelly in 1900. Kelly, a New York native, had as a child inherited four Natchez mansions, and as a young man he moved to Mississippi to claim his property. Whatever plans he and his wife had for Concord were lost when the house burned in 1901. The sweeping marble stairs and their iron balustrades stood alone for another half century, with weeds choking out any other trace of Natchez's first great mansion.

During those years of transition when the Natchez area went from being a Spanish province to an American territory, the region's destiny was changed forever by the perfection of Eli Whitney's cotton gin. Barely profitable indigo and tobacco crops became a memory, and cotton quickly came to dominate the economy and lifestyle of southwest Mississippi. Adding to the rapid technological advances in ginning, Rodney planter Rush Nutt developed a cottonseed strain that would thrive in the humid climate. The territorial years (1798–1817) saw the river counties filling with ambitious settlers, some arriving with only the clothes on their backs, others carrying the traditions and financial backing of landed families in the old Atlantic states. One who achieved early success was Revolutionary War veteran Benijah Osmun. He built a fine house on the Liberty Road, several rugged miles from Natchez. Originally a few simple rooms, Windy Hill Manor was later embellished to showcase the popular Federal style: careful symmetry in its one-and-a-half stories, a sweeping fanlight over the front door, and a windowed portico supported by four heavy Tuscan columns. Its crowning glory was the front hall's unsupported spiral staircase, which swept up to the bedrooms above.

Windy Hill stood at the end of a long avenue of cedars and was surrounded by moss-draped oaks; its setting was the scene of one of Natchez's most romantic stories. In 1807, Aaron Burr was roaming the old Southwest on a cryptic mission, possibly promoting secession of the territory from the United States. The former vice president had left Washington in disgrace after fatally wounding Alexander Hamilton in a duel, and his activities along the Mississippi River were viewed with much suspicion by local authorities. Burr was arrested near Natchez on charges of treason; his old friend, Benijah Osmun, offered him sanctuary at Windy Hill while he awaited trial. Local lore tells of a whirlwind romance between Burr and Madeline Price, a young woman who lived further down Liberty Road at Halfway Hill. As rumors grew of

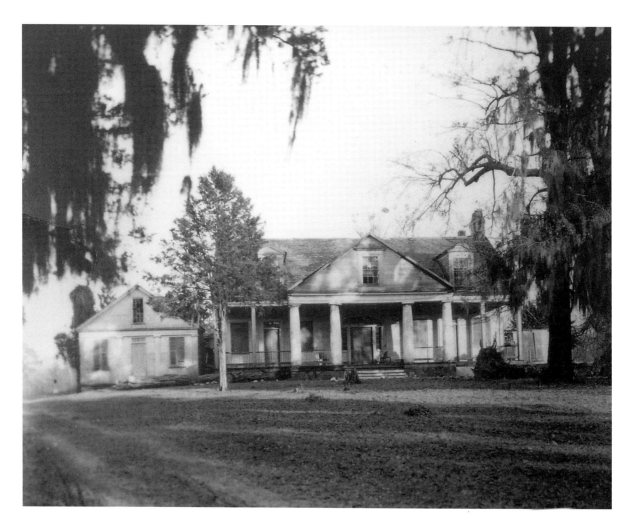

Windy Hill Manor, front elevation. Aaron Burr awaited trial for treason at Benijah Osmun's country home. Photo courtesy of MDAH.

Windy Hill Manor, rear elevation. Locked doorways led to empty spaces where entire rooms had rotted away. Photo courtesy of MDAH.

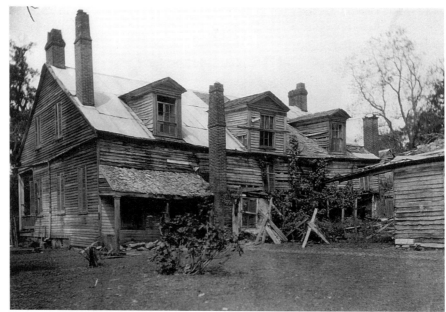

angry mobs and vengeful magistrates coming for him, Burr decided to make a dash for freedom, forfeiting a five-thousand-dollar bond. He spent much of that stormy night pleading with Madeline to accompany him, but honor or common sense held her at Halfway Hill. Burr slipped away before daylight and never returned to Natchez; years later, he wrote Madeline from Europe and released her from her vow to wait for him. She went on to marry an English nobleman and become the toast of society on two continents.

Colonel Osmun died in 1816. The following year, Windy Hill was sold to Gerard Brandon, who was destined to be Mississippi's first native-born governor. Brandon later passed the house down to his daughter, Elizabeth, on her marriage to William Stanton. Stanton was one of three Irish immigrants who made their fortunes in Natchez; his brother, Frederick, would build the ultimate Greek Revival town house of Natchez, Stanton Hall. William and Elizabeth had several children and enlarged Windy Hill to accommodate their growing family, adding side wings and several rooms to the original structure.

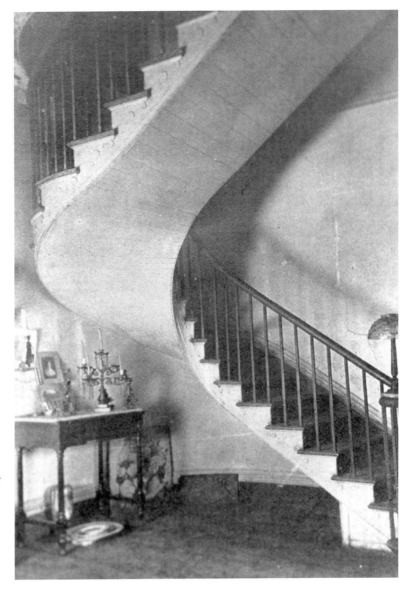

Windy Hill Manor, interior. The spiral stairway had to be dismantled board by board. Photo courtesy of MDAH.

Windy Hill Manor stayed in the Stanton family for more than a century. As the twentieth century progressed, the once-extended clan dwindled until only three maiden sisters remained in the rambling house. Miss Elizabeth, Miss Maude and Miss Beatrice struggled to maintain the family homestead in a changing world. Pride and tradition precluded the sale of any of their land or a single heirloom, and Windy Hill began to crumble around them. Entire rooms rotted away; the eccentric sisters would explain to visitors that those locked doors led to areas "under construction." The rear wing of the house sagged precariously, but remained attached to the original house. Paint peeled and shutters fell; by the 1930s, WPA photographers recorded a spectacle of pathetic deterioration at the end of the cedar-lined drive.

Well into her nineties, Miss Elizabeth died in 1942; Beatrice lived only a few more

years, leaving sister Maude alone in the collapsing house. Harnett Kane visited Maude in the mid-1940s and was horrified at the conditions he found on Liberty Road:

> Windy Hill Manor stood among the dark, shifting shadows of its trees. One of the small temple-like side wings was gone; its counterpart, with its peaked roof, huddled at the opposite end, under the protection of the porticoed main building. At the back two or three brick chimneys raised themselves forlornly out of the grass; the rooms that they had served had long since fallen. Vines clogged the old plantings, and weeds grew out of the brickwork and the clotted drains. . . .Under a lean-to waited the remains of the carriage in which the sisters once drove to town. Its shaft had broken, and tendrils of green had laced themselves about the unused wheels. Down the forgotten 'lover's walk' of Aaron Burr and Madeline Price we could make out the passageway near the broken terrace where the Stanton children had once played.[1]

Windy Hill sat empty and abandoned for twenty years, and was finally demolished in 1965 by a local cabinetmaker for its salvageable wood. It should have been a simple job, given the advanced state of decay that had set in over decades. The frame walls came apart easily and the floorboards were pried up without difficulty, but the gracefully curving stair refused to yield to the inevitable. Attempts to jerk it down with a truck wench were futile; the carpenter finally dismantled it by hand, board by board. When the fragments of the brick foundation were pushed into a bayou, the last traces of Windy Hill Manor and its place in Mississippi history were erased.

Natchez's antebellum reputation as a mecca for cotton fortunes grew along with the steamboat traffic on the Mississippi. Those boats were docking "under-the-hill" by the dozens, bringing adventurers and dreamers from eastern America and Europe. William Dunbar, son of a Scottish nobleman, was one who came to Natchez by way of Philadelphia. His original fortune was made in trading with the Indian tribes of the Northeast, but he had added to that wealth with tobacco and indigo crops in Louisiana. By 1792, he had moved his family to a plantation seven miles south of Natchez, building the original house known as the FOREST. An ornithologist traveling through the area described Dunbar's home: "[It was] a big square white plantation house deep in the oak woods. . . .The plantation was not elaborate but it was spacious. . . .The veranda of the plantation . . . stood one floor above the ground."[2] This description suggests that the original Forest was typical of the early Natchez-area mansions like Concord, with a brick ground level supporting a galleried main floor of frame construction.

A graduate of the University of Glasgow, Dunbar was a man who maintained an enormous range of interests despite his isolation from the academic centers of America. His areas of expertise included surveying, archaeology, and astronomy, and he was extensively involved in the volatile political climate of territorial Mississippi. Despite his Federalist leanings, he corresponded with Thomas Jefferson for more than a decade, and was nominated by Jefferson for membership in the prestigious American Philosophical Society. Needing intellectual stimulation from his peers, Dunbar was

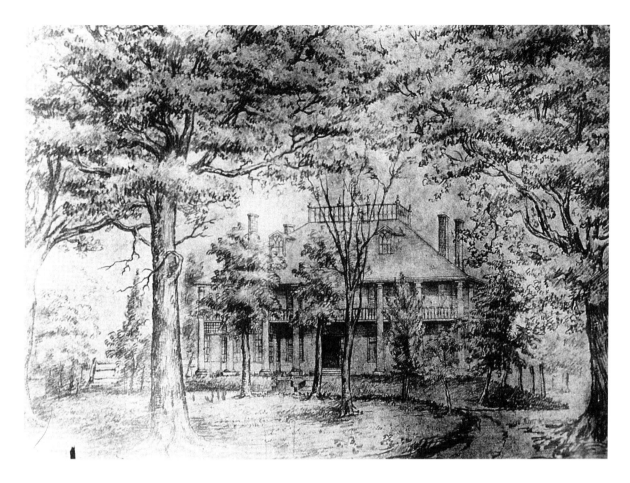

instrumental in forming the Mississippi Society for the Acquirement and Dissemination of Useful Knowledge; he and several other members of this ambitious group served as the first trustees of Jefferson College in 1802.

William Dunbar died in 1810, leaving his family an enormous inheritance. By 1816, his widow was overseeing the construction of a new house, but time has not recorded the fate of the original Forest. No mention is made in journals or letters of fire or storm damage, so it may have been that Mrs. Dunbar simply decided to build a grander house. Several of the early mansions of Natchez were being built or remodeled during this period, often under the direction of architect Levi Weeks. This Massachusetts native was responsible for such landmarks as Auburn and the East Wing of Jefferson College, and he may have been involved with the unusual design of the new Forest. Foreshadowing the grandeur of Dunleith and Windsor, this house was encircled by massive Doric columns, the first such peripteral treatment of a home in the Mississippi Valley.

The Forest was the domain of the Dunbar family for thirty-six years. William and Dinah's children and grandchildren lived there after Dinah's death in 1821, and several married into other prominent Natchez lines. Eliza Allen Starr, working as a governess in 1850, described the house and left the only existing sketch of the structure: "It is a large square brick mansion, surrounded by a double gallery. The rooms are

The Forest, from a sketch done by Eliza Allen Starr, governess of the Dunbar children. Reproduced by permission of MDAH.

magnificently large and high. . . . The halls and stairways are proportionately wide. The trees are too thick and the country too vast to allow of any distant view."[3] On a January morning in 1852, a chimney fire ignited the roofing tiles, and within hours the Forest was in ruins. A grandson of William Dunbar watched its destruction and recorded the day in his diary: "The family mansion house at the Forest caught fire this morning about 8 o'clock and in less than two hours burned to the cellars. . . . The regret for the loss of the noble edifice was not confined to the immediate family. It was endeared to a large portion of the community by the most pleasing association."[4]

The Forest was never rebuilt. Several of the original twenty-six columns still stand in the dense woods along Highway 61, south of Natchez. They are the only remaining evidence of the culture and refinement brought to frontier Mississippi by the remarkable Dunbar family.

Tucked away in the deep forests of Adams County, the Forest was built for maximum privacy, but some of Natchez's wealthiest citizens preferred to flaunt their success for all to see. One such nabob was William Dunbar's son-in-law, Samuel Postlethwaite. By 1821, this merchant and banker had acquired twenty-six acres of land on the Mississippi River bluffs, and he chose this most public of sites for his mansion, CLIFTON. John James Audubon's painting, *Natchez, Mississippi, in 1822,* is a panoramic view of the growing city, with the white columns and green roof of Clifton rising above the skyline of church steeples and red brick town houses. In the foreground of the painting, brick kilns mark the construction site of Rosalie; for forty years, Clifton and Rosalie would be the anchors of a park-like stretch of river bluffs. Joseph Holt Ingraham, describing the view from the river in *The Southwest by a Yankee,* depicted a scene of rare beauty in that developing corner of America:

> [There runs] a noble green esplanade along the front of the city; at the northern end of the esplanade, upon the beautiful eminence, gradually yet roundly swelling away from the promenade, stands [a] private residence . . . its lofty colonnades glowing in the sun—a magnificent garden spreading out around it, luxurient with foliage—diversified with avenues and terraces, and adorned with grottoes and summerhouses. Imagine these handsome residences, flanking the city, and forming the extreme northern and southern terminations of the broad terrace before the town, with the mighty flood of the Mississippi rolling some hundred feet beneath you—the dark forests of Louisiana stretching away to infinity in the west.[5]

Clifton was sold to Mrs. Anne Marie Linton in 1835. A devastating tornado that destroyed much of Natchez in 1840 left the solidly built bluff houses, Clifton and Rosalie, with only chimney and ornamental damage. After Mrs. Linton's death, the house passed into the hands of her son-in-law, Frank Surget, one of the most successful planters of his time. Surget owned thousands of acres of cotton lands in Louisiana, Mississippi, and Arkansas, but he maintained his home at Clifton.

The Surgets had enjoyed a quarter century of high living at Clifton when Natchez

surrendered to Union gunboats in 1862. Making the most of an unpleasant situation, many homeowners went right on with their social lives, simply expanding their guest lists to include Union officers who had commandeered the mansions as their head-quarters. Colonel Thomas K. Smith of Ohio took up residence in Clifton, and, in a letter to his wife, provided history with one of the most elaborate descriptions of the house:

> The house of Mr. F. Surget where I have been quartered for the past week is one of the largest and most elagantly [sic] appointed mansions in all the South, any description that I can give of its superb appointments will be but feeble. The proprietor counts his planta-tions by the dozens, his slaves by the thousand, those people I mean who were his slaves. . . . The mansion is very large. Great rooms with high ceilings, long wide halls, ample piaz-zas, windows to the floor and opening upon grassy terraces. . . . Everything that can minis-ter to refined taste almost is here. For the grounds you must imagine a chain of very high and steep bluffs bordering a wide river winding its silvery sheen far above and below, so ser-pentine in its course that miles and miles away, far off toward the setting sun, you can see its waters glittering in the last rays. . . . As you approach upon the broad carriageway that gracefully sweeps past the high columned portico, shaded by the Cypress and Magnolia and crape myrtles gorgeous in its bloom and blooming always. . . . One continually wonders that such a Paradise can be made on Earth.[6]

Frank and Charlotte Surget were gracious hosts, even for their enemies, and they shared their house with remarkable equanimity, given the circumstances. Dinner par-ties were held, with the guest lists carefully designed to include the appropriate per-sons. Tragically, the exclusion of a vindictive Union engineer at one such function would lead to a loss beyond Surget's imagination or control. Infuriated by the social snub, this officer decreed that the Natchez bluffs were inadequately fortified against Confederate attack; the only acceptable site for a fort, by sheer coincidence, was exactly where Clifton stood.

Frantic protests fell on deaf ears, and the Surget family was given twenty-four hours to vacate the house. The next morning, a large crowd gathered to watch dyna-mite charges blow Clifton's marble mantels, rosewood statuary and cut-glass window panes into the Mississippi River. A family friend, Maria Sessions, remembered the scene many years later:

> I had just reached home after coming in from the plantation, when I heard that the Yan-kees were about to demolish Clifton. . . .When we reached Main Street I saw what a state of excitement the people were in. They were at fever heat. . . . Apparently, all of Adams County had heard of the threat to dynamite Clifton. . . . I saw Lotte [Mrs. Surget] standing near one of the colonnades that upheld the double-decked portico; she was holding her large, silver coffee pot, the sugar bowl and the teapot in her arms and was looking out over the crowd; evidently, she was afraid to move for fear she would drop some of the

pieces. . . . 'Time's up!' Captain Hays shouted. He was standing only a few feet away. Then he snapped his watch shut. Two men jumped forward and began to crowd us farther back on the lawn. Yankee soldiers sprang up in every direction. 'Clear the grounds! . . . clear the grounds! . . . clear the grounds,' they yelled. The troops crowded people back so rapidly that everyone began to scream at once. . . . After so long a time we found ourselves under a sweet-olive tree that stood some distance from the house. But we were not far enough away to fail to hear the thud of the ax as it crashed the front door from its fluted pilasters and felled it out upon the mosaic floor of the portico. Almost at the same moment Frank [Surget] was silhouetted against a fire which had flared up in the vestibule. He stood there, looking neither to the right nor to the left. Then he walked down the marble steps, as though to his death. . . . Billows of black smoke had already begun to roll from the doors and windows of Clifton. Lotte and I hesitated a moment. But the smoke was growing denser and we were choking and coughing until we could scarcely speak. . . .We were still confident that Clifton would not be *entirely* destroyed . . . the dynamiting of a mansion such as that was too fantastic a thing to consider possible. . . . Suddenly, there was a great roar. Fragments of wood and iron came hurtling through the air. . . . The roof was still there, but evidently it was badly damaged. Looking east we could see that the entire front and one side of Clifton was a mass of flames. As we watched, the big house appeared to sink downward into a blazing heap. Then there was a second detonation that sounded and resounded up and down the hillside. . . . As the buggy [was turned] about I got a full view of Clifton. For a few seconds I gazed at the smoking, fiery pit wherein lay smouldering bits of the house in which I had spent so many happy days. . . .[7]

A large earthwork fortification, Fort McPherson, was built up on the site of Clifton. Several other Natchez mansions, including Airlie, Riverview and the Burn, were within its boundaries. The gun placements were never used, and even the Union general whose name was given to the fort found the whole situation excessive. Frank Surget never recovered from the shock of seeing his treasure so callously destroyed; before he moved permanently to France, he commented on the ill-fated dinner party that set the disaster in motion: "It was assuredly not an intentional afront [*sic*]. I would have asked the devil himself to dinner if it would have saved Clifton."[8]

Clifton's site on the bluffs was logical. High above the threat of floodwaters and the ever-changing course of the river, the house afforded views of Louisiana that were unmatched. In contrast, the thin strip of land beneath the bluffs had, since the earliest days of Natchez, attracted only rough characters and the shady businesses that served them; none of Natchez's new aristocracy considered building their mansions "under-the-hill." It would take the vision of Scottish immigrant Andrew Brown to bring beauty to the base of the bluffs.

Brown arrived in Natchez around 1820, boasting some expertise in architecture and construction skills. He soon formed a partnership with Peter Little, the master of Rosalie, and Brown may have been responsible for the design and erection of that landmark house. The old Masonic Temple (torn down in 1890) and the First Presbyterian

Church were also Brown's handiwork, and commissions from such projects as these allowed him to buy Little's profitable sawmill in 1828. The mill was tucked between the river and the bluffs, directly beneath Clifton's grounds. Brown quadrupled the size of the mill operation and began to lay plans for building his house nearby.

The first house built by Andrew Brown was probably destroyed in the devastating tornado that swept through Natchez in 1840. This home was just north of his mill, wedged between the bottom of the steep bluffs and the riverbank. When it came time to rebuild, he chose the same spot, flaunting the prevailing trend toward town houses and country manors. Harnett Kane described the home, which would come to be known as MAGNOLIA VALE:

> A wide stuccoed-wooden structure, two-storied, it took the shape of an E, with three wings to the back; before it stood a simple, neatly balanced gallery with a double set of four Doric columns, supporting a tasteful shingled roof. [Brown] saw that there would be light and air in practically every room. The house itself could be divided into a series of separate apartments. Rear galleries opened into an expansive courtyard, bordered by a thoroughly untypical three-storied wooden fence, the highest Natchez ever had. It was a rectangle that enclosed a yard, chicken house, smoke house, wine-press and storage house. Even from the nearby road along the hillside, the Browns had full privacy. Only the two-storied, columned front was visible. Another court, a small open one, was created before the house, its outer corners guarded by a set of statues, depicting the four seasons. . . . They looked out upon what was to become a Natchez wonder, 'Brown's Gardens'. . . . [Andrew Brown] had fifteen or more acres with which to work and upon them he lavished all of his feeling for green things. At the entrance he built up two mounds of earth, each topped by a tree; between them he put up an arched white gateway. From there to the house was a distance of some twelve hundred feet. Along it he set an avenue of magnolias, interspersed with shrubs. . . . At both sides of the aisle of trees were circles, quarter circles and triangles of growth, carefully and precisely separated. Cherry laurels, oaks, magnolias and poplars were interspersed with both plain and showy shrubs. . . . Orange trees flowered near the foot of the hill. Wisteria dropped at the corners, and along brick paths the coral of crepe myrtle spread in waves. . . . Near the house several high natural mounds raised themselves; atop one of them he constructed an 'outdoor living room', a circular, topless retreat, with benches inside and a round of tall cherry laurels to shut out the world.[9]

Brown's Gardens came to be one of antebellum Natchez's premier attractions. Steamboats docking at Silver Street would allow their passengers ample time to rent a hack and ride through the flowering estate. Andrew Brown's skill at gardening was apparently equalled by his business acumen; the mill operation grew to be the largest in Mississippi, supplying lumber for the numerous mansions under construction in the 1850s. When Brown died in 1870, ownership of Magnolia Vale and the mill passed to his stepson, Rufus Learned, who married Brown's only daughter. Learned expanded the family business to include icehouses, steamboats, railroads and banking inter-

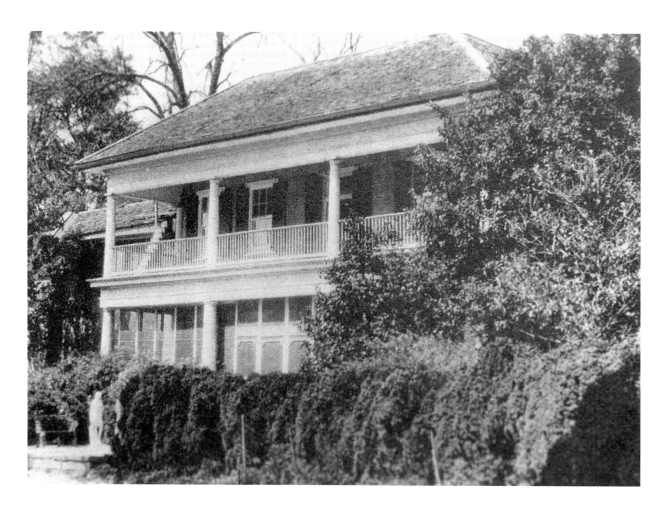

Magnolia Vale, the only Natchez mansion built below the bluffs. Photo courtesy of MDAH.

ests. By the 1890s, he was the richest citizen in Natchez. But all the money in the world could not hold back the creeping erosion of the land under Magnolia Vale; Andrew Brown had defied nature in building his empire under the bluffs, and the river was gradually eating away at the gardens. Learned spent a small fortune having a series of chains and concrete piers installed under the house, securing its place as the gardens disappeared bit by bit into the river.

Magnolia Vale was passed down to Rufus Learned's son, Andrew Brown Learned, who chose to build a new home on higher ground. The old house was left in the hands of caretakers. It burned in December 1946, and was replaced by a similar house built on the old foundation.

The early provincial and Federal architectural styles in Natchez gave way to Greek Revival trends in the 1830s, and it is those massive columned mansions that most readily evoke the antebellum period in the minds of modern visitors. During the three decades preceding the Civil War, the town's elite engaged in an unequalled building frenzy, with each new house having to be a little bigger and finer than its neighbors. Many of these solidly built structures have survived, including that perpetual symbol of the Natchez pilgrimage season, Stanton Hall. Frederick Stanton's home represents the epoch of Greek Revival styling in southwest Mississippi. Its fluted capitals stood

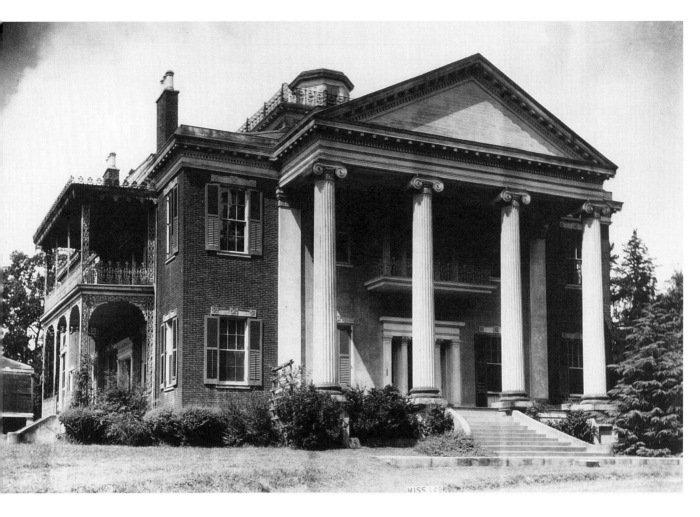

higher than any other, and it showed touches of the Italianate influence that was coming into vogue in the 1850s. But while Stanton was building his palace downtown, David Hunt was matching him brick for brick out on Pine Ridge Road. H O M E-W O O D , during its eighty-year existence, would be just as famous and frequently photographed as Stanton Hall.

David Hunt labored for years in his uncle Abijah's mercantile stores, and inherited the older man's fortune when Abijah died dueling with future governor George Poindexter in 1811. Over the next fifty years, Hunt parlayed that original stake into an empire that was phenomenal even by the inflated standards of antebellum Natchez. Upon marrying, each of his seven children was presented with one of his twenty-five plantations. Daughter Catherine, engaged to William Balfour, received the land known as Homewood Plantation, just northeast of Natchez. Architect James Hardie designed a Greek Revival/Italianate mansion fronted by thirty-foot iron columns and topped by an observatory. Delicate wrought-iron porches on either side of the three-story house balanced the massive classic pediment of the front facade, and the rear featured double galleries enclosed by louvred shutters.

Inside, four hallways formed a Maltese cross, separating the huge formal rooms on

Homewood. David Hunt's wedding present to his daughter was destroyed by fire in 1940. Photo courtesy of MDAH.

the main floor. Catharine Van Court described the interior in 1937: "On the first floor there are six rooms. The library, reception hall and drawing room may be thrown into one salon, seventy-two feet long. The sliding doors here are of mahogany, three inches thick, rubbed to a dull luster. All doorknobs and hinges on this floor are of solid silver. The stairway, leading from the central hall, curves continuously from the lower to the third floor; the steps are fan-shaped and the handrails are of black walnut. In the library, the hand-carved mantel is of pink marble delicately veined in gray. The mantel in the drawing room is of white marble and in the dining room, of pink marble mottled with oxblood."[10] The second floor duplicated the first with six enormous rooms and four hallways, and the third floor provided cedar-lined closets in an octagon arrangement. A hexagonal cupola topped the roofline, providing views across the park-like grounds.

More than a million bricks were fired on the grounds of Homewood; construction took five years and was barely finished when war took William Balfour away. Catherine Hunt Balfour stayed with the children, watching four of them die in the great echoing rooms of Homewood. The Balfour family remained at Homewood until 1907, and the house passed through several families during the next three decades. On the night of January 2, 1940, firefighters were called too late to salvage the blazing mansion; just the blackened brick walls and the iron columns were left by sunrise. Only a two-story dependency, converted into a private home, remains to mark the site of Natchez's largest and grandest country home.

Woodville

The southwest corner of Mississippi is the repository of the very earliest history and lore of the state. Soldiers of fortune were drawn to this isolated area, along with planters looking for fertile lands; with the incorporation of the area as Wilkinson County in 1802, the more respectable element became dominant. As the population center shifted from Fort Adams to Pinckneyville and, finally, to Woodville, great fortunes were made and the obligatory mansions appeared throughout the county. Many remain; some have been lost to the inevitable fire and neglect; several have simply disappeared into the forests that reclaimed the land as agricultural interests declined.

Woodville developed not only as a farming center, but also as a social and business hub. Mississippi's first railroad, the Woodville and West Feliciana, ran from there into Louisiana, and the state's oldest newspaper is still published in town. Several of Mississippi's Protestant denominations date their original congregations back to Woodville, and Jefferson Davis's family lived at Rosemont, east of Woodville, for many years. In this atmosphere, a number of exceptional houses were built, both in town and in the surrounding countryside. Wilkinson County seems to have had an unusual tradition of preserving columns; the sites of three of its grandest houses are marked by these enduring remnants of the antebellum era.

Edward McGehee, a Georgia native who moved to this burgeoning territory in 1808, was one of Wilkinson County's first success stories. Over the next half century, he would become not only one of Mississippi's wealthiest cotton planters but a businessman of exceptional skill. He served as a founder of the Woodville Bank, as a promoter of the railroad and as owner of McGehee Mill, which boasted four thousand spindles and eighty looms and employed hundreds of workers in the manufacture of cotton cloth. Somehow, McGehee found time to serve several terms in the state legislature, and became well enough known for his political and business acumen to be offered the post of secretary of the treasury in Zachary Taylor's administration.

The centerpiece of Colonel McGehee's five-thousand-acre plantation was his home, BOWLING GREEN. Constructed during the 1830s, it was most likely a Federal-style mansion, although no photos or sketches survive to document this. Vindictive Kansas cavalrymen, furious at finding the mill still producing Confederate uniforms in 1864, torched the factory and the house, leaving only the four columns of

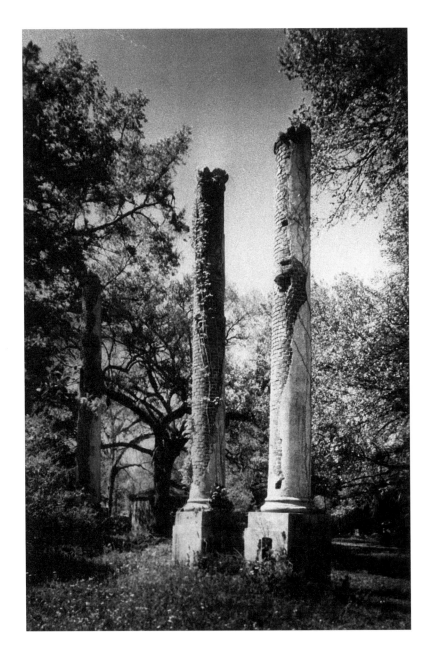

Bowling Green columns. Edward McGehee's mansion was burned by vindictive Federal troops. Photo courtesy of Mary McGehee, Wilkinson County Museum.

Bowling Green standing over a rubble-filled cellar. Novelist Stark Young, a cousin of the McGehee family, based his fictional account of the incident in his 1934 novel, *So Red the Rose,* on family history:

The cotton ginhouse across the pasture from the house had been set afire and was burning. Hugh found his wife in the hall, with her back against a door. The house was going to be burnt in twenty minutes, he said. They could save what they could. . . . The destruction had already begun. The table in the dining room, which had been laid for breakfast, was overturned and smashed for kindling a fire in the middle of the floor. The china closet was

crashed up. They could hear axes smashing over the house, splitting up banisters and furniture for the fire. The pictures on the walls were being slashed or cut down . . . soldiers were pouring turpentine over the library and a sheet of flame spread there. . . . Not long after, flames poured from windows, and down the long hall a torrent of smoke and flame rushed out through the door. Timbers crashed and then the roof fell in. The columns of the front portico remained standing.[1]

The family had managed to pull the grand piano out of the parlor; all of their other possessions were lost in the fire. After the war, Colonel McGehee, his fortune gone, built a more modest house over the cellar, leaving the original columns standing in front as a reminder of all that he had lost. On a cold January morning in 1941, the second house also burned, and once again the grand piano was the only item salvaged.

Three of Edward McGehee's "reminder" columns remain standing on the old homesite; the fourth vanished one night, presumably scavenged for its bricks. Close by, the brick carriage house is the only other evidence of Bowling Green's glory days. Across the winding country road that leads to the plantation, the McGehee family cemetery is well maintained, the colonel's shaft rising above all others.

West of Woodville, James Alexander Ventress established his own reputation as a talented planter and politician. Born in Tennessee, Ventress moved to Woodville as a small child, and he grew up as a contemporary of young Jefferson Davis, whose family lived at Rosemont. Having taken advantage of the available resources for schooling in Mississippi and New Orleans before attending the University of Edinburgh, Ventress was extraordinarily well educated for a citizen of the frontier.

After returning to Mississippi, Ventress divided his time between planting cotton and serving in the state legislature. His was not a token term of office in Jackson; he was elected speaker of the house and authored the legislation that established the University of Mississippi. Determined that his children and those of his neighbors would be able to pursue their education without leaving the state, Ventress served on the university's board of trustees from its inception until his death in 1867.

Ventress's plantation home, L A G R A N G E, was originally a one-story structure, sitting along the old road to Pinckneyville. Ventress was a world traveller and was undoubtedly well acquainted with classical architecture; at some point, he decided to expand his house into one to rival the masterpieces appearing in Natchez. Intrigued by the designs that Philadelphia architect Samuel Sloan was developing for Haller Nutt's Longwood, Ventress contracted with the Pennsylvanian and his crew to add a second floor and classically inspired colonnade to LaGrange. Working frantically as rumors of war grew, the carpenters added two-story columns of stuccoed brick topped with unusual Oriental capitals, and the entire hipped-roof structure was crowned by an elaborate cupola. Many of the details in LaGrange's facade, such as brackets and cornices, mirrored those of the more flamboyant shell that was Longwood.

Perhaps the work on LaGrange contributed to the delay in completing Longwood; at any rate, LaGrange stood for another fifty years before it burned. As at Bowling

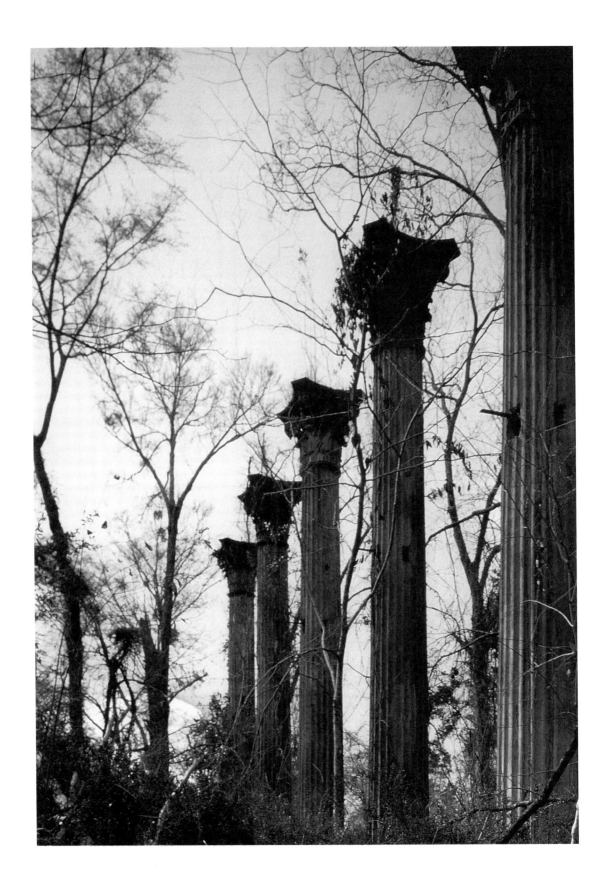

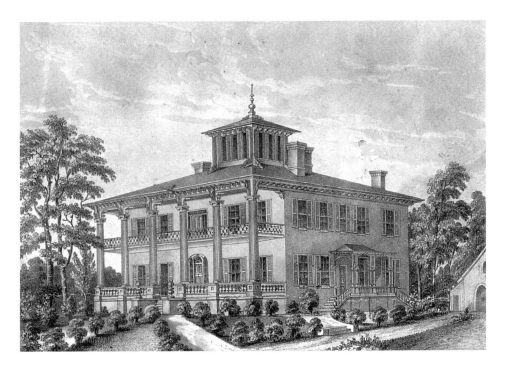

LaGrange, home of Alexander Ventress. Samuel Sloan designed a second story for the house, adding Oriental elements similar to those on Longwood. Photo courtesy of Wilkinson County Museum.

Green, a new house was built on the site, but it was a pale shadow of the magnificence of the original house. In another echo of Bowling Green, two of the columns were left standing, towering over the farmhouse porch. Aside from a sagging antebellum servants' quarters immediately behind the house, they are the only hint that a unique home once rose at this bend in the road. Much of their height has crumbled away and the extravagant capitals have long since gone for scrap.

Deep in forested isolation, the columns of the GROVE are a riveting sight. The house was built by Joseph Johnson, a Tennessee native who helped write Mississippi's 1817 constitution and later served as the first president of the West Feliciana Railroad. No photo, sketch or eyewitness description of this house exists; it burned in 1899, leaving five monumental Corinthian columns standing over great slabs of granite, presumably part of the front gallery. It seems from the size and placement of the columns that the house must have been built on a grand scale. An ornate silver service, bearing dents from having been buried during the Civil War, was rescued from the burning house and now sits in the Wilkinson County Museum.

The Grove columns. Five Corinthian columns are all that remained following an 1899 fire. Photo courtesy of Mary Rose Carter.

All but forgotten after a century, the road to the house has worn away, and what must have been well-landscaped grounds have given way to dense forests and vegetation. Vines climb the five standing columns, lined up like eternal sentinels with nothing left to guard. A sixth column lies shattered in the thick undergrowth, its massive Corinthian capital slowly rusting among the leaves.

21

Woodville

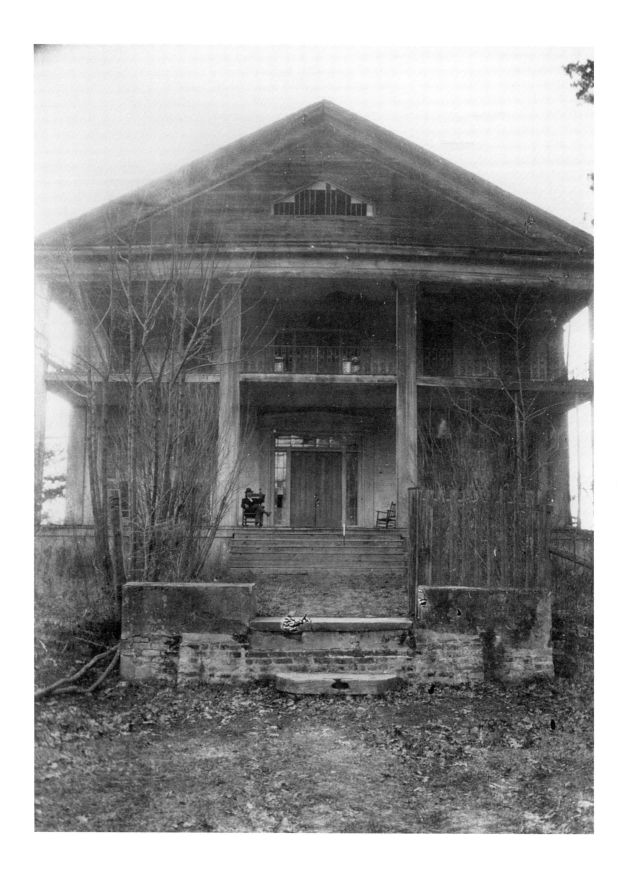

Port Gibson

Upriver from Natchez, Claiborne County was carved out of the territorial wilderness in 1802. Samuel Gibson donated land along Bayou Pierre to establish a county seat, and the town that took his name would be so gracious and inviting sixty years later that Ulysses Grant would choose not to put it to the torch. Whether or not he actually declared Port Gibson "too beautiful to burn," Grant and his troops saw some of the finest houses in Mississippi as they marched from Bruinsburg to Vicksburg in 1863.

Bayou Pierre winds through the hills of southwest Mississippi like a snake, its overflows laying down a rich bottomland that seemed to be created for cotton. Planters in nineteenth-century Claiborne County reaped fortunes from this dirt, and like their "city" counterparts in Natchez, they spent at least a part of those fortunes building ever-larger houses. Port Gibson had its fine town houses, but most of the largest mansions were scattered around the county in an ostentatious display. A 1976 history of Claiborne County lists page after page of country estates that are now almost altogether vanished, most without photographic documentation. The FLOWERS HOUSE, at Reagonton, stood from 1832 until 1937, a monumental home with its own ballroom on the third floor. When it was razed, seventy thousand bricks were salvaged, along with a spiral stair and a huge portico. The bricks were used in other homes, and the stair and portico were lost to fire while in storage. Another forgotten home mentioned in the county history was the HAMMER HOUSE, near Rocky Springs, described as "truly a mansion. It was a two-story building with beautiful columns extending from the first-floor galleries to the roof of the second floor. Evidently there were galleries on all sides of the house. This home was famous for its beautiful woodwork. . . . The most notable feature probably was the swimming pool on the top of the house. . . . About 1940, the house had been razed, but the foundations and the columns still standing were reminders of the ruins of Windsor. The columns still stood around the entire foundation. . . ."[1]

Closer to Port Gibson stood ANCHUKA, home of the Archer family for nearly one hundred years. Anchuka is the Choctaw word for "home," and this particular home had a history straight out of a Gothic novel. Richard Archer was a native of Virginia who bought land in Claiborne County in 1824. He also developed a sizable agricultural empire in Holmes County, but married into an old Port Gibson family and

Anchuka, front elevation. The Archer family mansion was almost uninhabitable by 1930. Photo courtesy of MDAH.

chose to build his mansion there rather than in Lexington. Anchuka, begun in 1835, was the center of a 1250-acre plantation on Bayou Pierre. Overlooking the fields from a heavily wooded hill, the Greek Revival house rose a full two stories above a ground-level basement. The temple-style facade was fronted by square columns supporting the upper and lower galleries. Broad front steps led to the panelled front doors.

Anchuka's floor plan of sixteen rooms included some conveniences unheard of in those days. Each bedroom had a "dressing closet" and the second floor boasted a unique "shower bath." This was a cement vault sunk into the floor, accessible by steps and powered by a servant pouring water through a crude shower arrangement. These upstairs wonders were reached by way of a tight spiral stair built into the wall between the library and dining room.

Anchuka was also notable for its unusual slave quarters. Rather than building individual cabins, Archer devised a 150-foot-long structure with double galleries, each floor containing twelve rooms for servant families. Each gallery ended in massive masonry fireplaces that provided cooking space for the house.

By the 1890s, ownership of Anchuka was split among the ten Archer children, and the house's story took a regrettable turn. Out of style and difficult to maintain, the old place was all but abandoned for the next quarter century. Slow deterioration and vandalism took a steady toll. When the last remaining family members died in the 1920s, a farm manager moved into four downstairs rooms of the crumbling mansion, protecting himself from falling plaster by installing a tent over his bed. The once-magnificent grounds were rapidly returning to wilderness, and the slave quarters rotted behind the main house. A visitor to the spooky shell of a house recalled its appearance in 1927:

> The building, although structurally sound, was deteriorating rapidly for lack of maintenance and repair. Large pieces of the beautiful fresco and plaster works were falling with increasing frequency, exposing underlying hand-hewn lath that was attached to the joists and studs by wood pegs. Bees had established large hives in the exterior west and north walls beneath the heart cypress lap siding, and portions of the front and back porch floors were weakened by decay. Many of the window shutters were loose or falling, and water damage occasioned by roof leaks was evident on both floors and ceilings. A thick veil of dust covered everything and the musty odor, typical of a long vacant and closed house in a southern climate, was overpowering. . . . The school room on the half story above the second floor was still well equipped with text books, chalk, erasers . . . and the usual appointments associated with a schoolroom. Except for the deep layer of dust and the faded maps . . . everything was as though class was suspended for a fifteen minute recess and would resume shortly. . . . The only objects that failed to show stress were the beautiful spiral stairway between the first and second floors, the marble mantels that adorned the fireplace in each room, and the famous sunken shower bath on the second floor.[2]

Outside the house, the creeping vegetation was enough to discourage all but the most determined visitors. Crepe myrtles, untrimmed for decades, had grown so tall

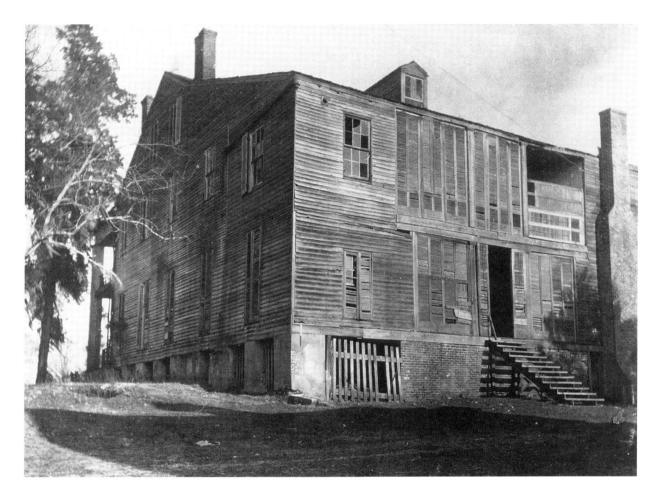

that they totally blocked light from reaching the house. The heart-shaped drive was overgrown with weeds and rutted to the point of impassibility. Still, the farm manager hung on in his little corner of the house, now shared by his disabled son. On a summer day in 1930, both were killed in a car-train collision not far from the mansion; Anchuka was never inhabited again. A sadly faded shadow of its original glory, it was torn down in 1940. The marble mantels found their way into a Vicksburg home, but the famous cement tub was hauled to the scrap heap along with the carefully molded plaster medallions and cypress woodwork. The site, now a hunting reserve, offers not a clue that Anchuka ever existed on the wooded hilltop.

North of Port Gibson, near the present site of Grand Gulf Nuclear Plant, Charles Darius Hamilton built a fine house with a much happier history. A transplant from Frankfort, Kentucky, Hamilton was a successful planter who built HIGHLAND HOUSE in 1856. This was a most unusual southern home, a rambling one-story structure with a central courtyard that was twenty-five feet square. The eleven rooms of the main house opened onto this courtyard, which was used as a summer living room and, occasionally, as a ballroom. A long wing ran off the left rear of the house, and two large latticed summer houses flanked the main house on either side.

Charles Hamilton's family included eight children, the last one born in the midst

Anchuka, rear elevation. The rear portico was closed in with shutters pulled from the side facades. Photo courtesy of MDAH.

Port Gibson

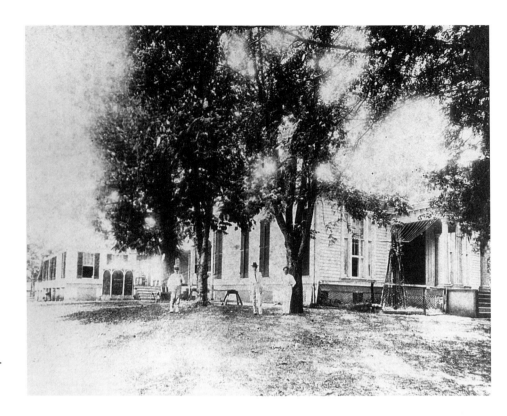

Highland House, exterior. This Grand Gulf house was in the path of Grant's march to Vicksburg. Photo courtesy of Gene Sulser.

Highland House, interior. The formal rooms opened onto an interior courtyard. Photo courtesy of Gene Sulser.

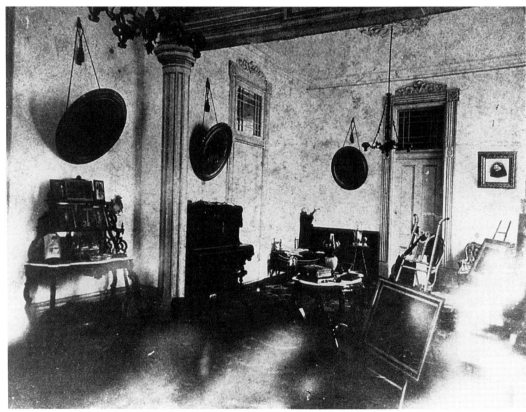

of the skirmishing as Grant's army headed toward Vicksburg. Mrs. Hamilton sent word to the general that leniency would be appreciated at Highland, and Grant responded by having his troops return pillaged goods and sending a wagonload of his own stores. This bit of courtesy amid chaos was surely appreciated, but gratitude only extends so far: Mrs. Hamilton named her newborn son Robert E. Lee Hamilton.

Robert Hamilton grew up at Highland, as did the next generation of his family, but by the 1920s the rambling house was being occupied by renters. In 1929, a fire leveled it, and its location has been covered behind the modern fences of Grand Gulf Nuclear Station.

Southwest of Port Gibson, the Civil War brought an abrupt halt to work on another man's dream. In 1861, a Mr. McGill was laying the foundation for a house to upstage his neighbor, Smith Daniell. Had he succeeded in getting his house off the ground, McGill would have had quite a palace: he was attempting to overshadow no less a landmark than Windsor, probably the largest and grandest mansion ever seen in Mississippi.

When Smith Daniell set out to build WINDSOR in 1859, he fully realized that he was creating a remarkable structure even in a state known for its showplaces. Tragically, he would inhabit the finished house for only a few weeks after its 1861 completion; he died at age thirty-four. The supposedly "fireproof" house itself would stand a brief thirty years before collapsing in flames, but its Corinthian columns would remain a century later as a symbol of Mississippi's lost cotton kingdom.

Windsor was the centerpiece of a plantation that consisted of more than twenty-six hundred acres. Daniell also owned twenty-one thousand acres in other parts of the state and in Louisiana. For his ultimate house, he chose a homesite three miles inland from the river port of Bruinsburg. Slaves burned thousands of bricks in a kiln across the road from the construction site; expert masons and carpenters were brought down from New England to do the actual brickwork and millwork. As the four-story structure took shape, twenty-nine huge columns were formed of molded brick and plaster, their height reaching thirty feet. Cast-iron Corinthian capitals, each larger than a man and weighing hundreds of pounds, were placed atop each column. These capitals, along with elaborately scrolled balustrades and four sets of broad stairs, were manufactured in St. Louis and shipped downriver to Bruinsburg.

The columns sat on panelled stiles, each a full story in height, allowing the house to rise over a full above-ground basement. The basement, an entire plantation community in itself, included storage rooms, a dairy, commissary, doctor's office and a schoolroom. If this level was functional, the two floors above it were sheer elegance. Central halls divided twenty-three rooms, with three huge rooms (nineteen by twenty feet) on each side of the hallways of the main floors. On the first level, double parlors, a library, and the master suite, consisting of a bedroom, study and bath, filled the main block of the house. A spiral stair rose from an offset of the main hall, leading to the second living level with its bedrooms and another bath. Water for the baths was supplied by storage tanks in the attic. A three-story wing on the rear provided kitchen

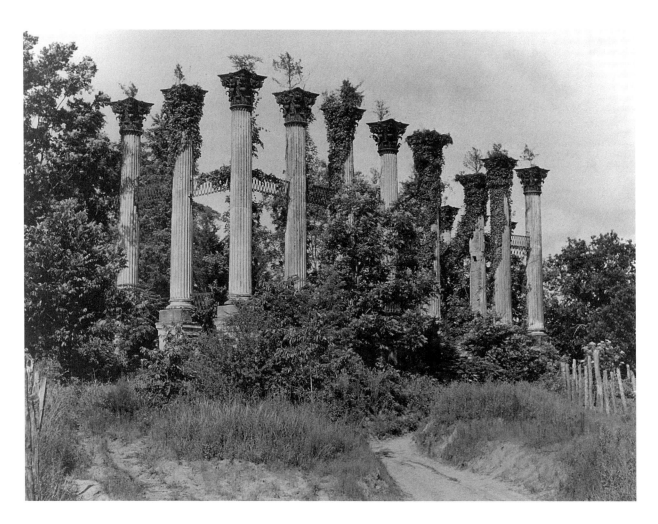

Windsor's columns. Smith Daniell's masterpiece stood for only thirty years. Photo courtesy of MDAH.

and pantry space, a dining room and still more bedrooms. Topping the whole magnificent pile was an observatory, its hipped roof supported by smaller versions of the main Corinthian columns. From this summit, Smith Daniell could see his entire Mississippi plantation and much of his land across the river in Louisiana. Eight chimneys broke the roofline of Windsor, their shafts drawing smoke from twenty-five fireplaces fronted by marble mantels.

In spite of Smith Daniell's premature death, Windsor fulfilled its destiny as a center of hospitality; it also saw uses that he had never envisioned. As Union gunboats moved up and down the Mississippi River, Confederate scouts signalled to their Louisiana counterparts from the observatory. Grant's army marched right past the front steps of the mansion, and Lieutenant Henry Otis Dwight stopped to sketch the house in his diary. That drawing, the only known rendering of Windsor by an eyewitness, lay hidden in the Ohio archives collection for 130 years. It was labeled "Residence near Bruinsburg, Mississippi," leaving no doubt that Windsor was the subject of Dwight's pen.

Following the Battle of Port Gibson, the basement level of Windsor was used as a hospital for Union soldiers; perhaps for that reason it was spared the torch that

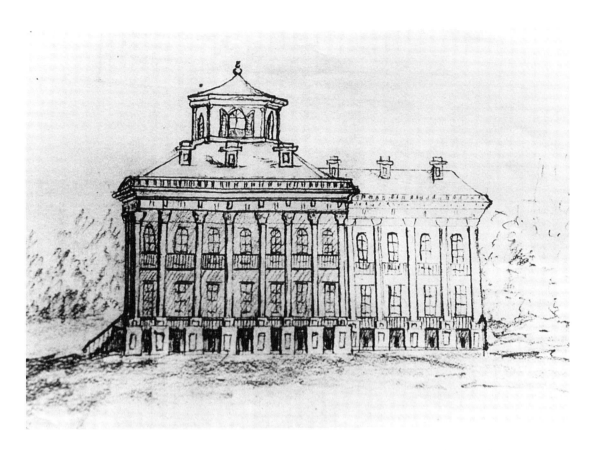

brought down so many of its neighbors. Windsor would survive the perils of war and a devastated economy, only to be lost to carelessness. A house guest, casually flicking his finished cigarette into sawdust left by workers repairing the observatory, set off a conflagration that left the mansion a pile of rubble. The local newspaper reported on the loss in its February 21, 1890, edition:

> The palatial dwelling on Windsor plantation, near Bethel Church in the southwestern part of the county, burned to the ground last Monday. The fire . . . was discovered about noon, but it could not be checked, and in a few hours this splendid country site was in ruins. Most of the contents were also destroyed. These included not only a great deal of elegant furniture, but many costly heirlooms and much other household property of value, such as jewelry, silver plate, a large library, etc. . . . This residence, probably the most magnificent in the state, was erected by Mr. Smith Daniell shortly before the war. It was a brick structure, comprising 25 rooms and was completed, we believe, in 1859. The building cost $140,000, and furniture $35,000 additional, bringing the total cost to $175,000. . . . We regret to learn that neither upon it nor its contents was there any insurance.[3]

Smith Daniell's dream had disappeared in a single afternoon. Remaining were twenty-two of the towering columns, a few sections of balustrade still clinging between them, and one set of the elaborate ironwork steps. The countless handmade bricks, the imported marble mantels and twenty-five rooms of expensive furniture lay

Windsor, as sketched by Lt. Henry Otis Dwight. This is the only known existing representation of Windsor done by an eyewitness. Reproduced by permission of the Ohio Historical Society.

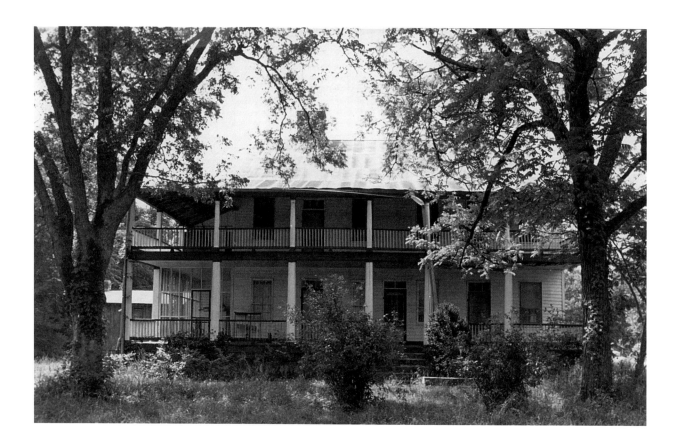

Laurel Hill, near Rodney. Dr. Rush Nutt's innovations opened the way for Mississippi's cotton kingdom. Photo courtesy of MDAH.

in a smoldering mass of ruin. With time, the rubble was cleared away and the family moved to Port Gibson. The columns were untouched; perhaps it was assumed that the violent storms rolling across the Mississippi River into Claiborne County each spring would take care of them. Years passed, and the columns remained, almost in defiance of the elements, vines creeping up their fluted plaster and vegetation sprouting through the iron capitals. Occasionally, a piece of plaster would break away from the crumbling brickwork, but the columns held fast. In 1974, they were officially given to the state of Mississippi for upkeep.

If Windsor epitomized the apex of Mississippi's cotton-generated boom times, LAUREL HILL represented its origins. Located near Rodney in Jefferson County, this simple double-galleried frame house was built in 1815 by pioneer physician and inventor Rush Nutt. He had left his well-to-do family in Virginia in 1805, establishing himself in one of the most isolated areas of the Southwest. Nutt was responsible for two innovations that indirectly led to the economic success of planters in the decades preceding the Civil War. His breeding of Petit Gulf cotton led to explosively larger yields, and his adaptation of Eli Whitney's cotton gin for steam power allowed the tons of white gold flowing out of the fields to be processed much more quickly.

While his fellow Mississippians built ever bigger houses, Dr. Nutt was content to raise his family at Laurel Hill, isolated at the end of a sunken road east of Rodney. The

CABINETS

DN

JIB
DOORS

UP

LATER
DOORWAY
(ORIGINALLY SOLID WALL)

Laurel Hill, floor plan.
Reproduced by permission
of MDAH.

unique nature of this house was evident in its front facade; a combination of four windows and three front doors greeted visitors. After entering the center door, one stepped into a tiny vestibule, approximately four and a half feet wide. Leading almost directly upwards was a simple stair, and two nineteen-by-nineteen-foot rooms opened off each side of this foyer. A rear central hall also opened onto two rooms. Closets and built-in cabinets were innovations devised by the creative Dr. Nutt. Upstairs, several rooms opened off the central hall; the stairs to the large, cypress-beamed attic were tucked away in an enclosed stairwell.

Dr. Nutt's son, Haller, grew up at Laurel Hill. Haller Nutt's never-finished Natchez home, Longwood, was the last burst of southern opulence before war brought the cotton barons' dominance to an end. Longwood, fortunately, survived decades of neglect and near-abandonment to become one of Natchez's most popular attractions. Laurel Hill's fate was not so kind. After serving 150 years as a gracious country home, it was systematically dismantled and its remnants left to burn by its last owners.

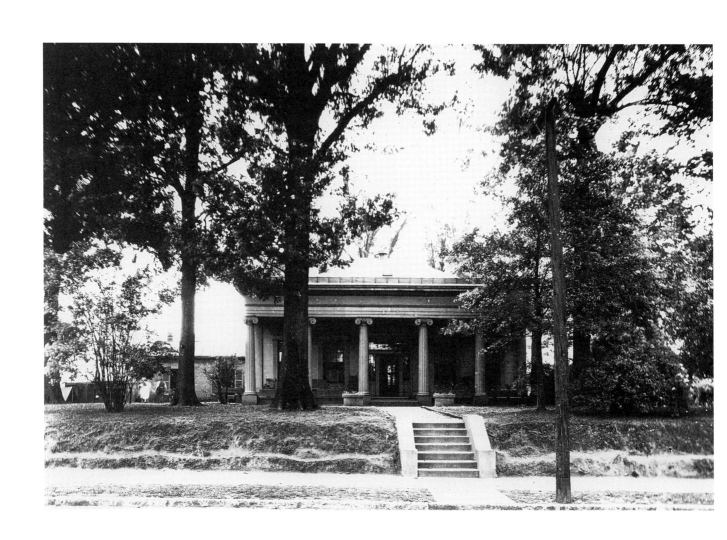

Vicksburg

The history of Warren County is inextricably linked to the Mississippi River, the area's fortunes rising and falling like the river's spring floods. A finer location would have been hard to find in territorial Mississippi: high bluffs protected settlements from overflows, and rich cropland surrounded the town on three sides. The river provided ready transportation for business and population growth. These advantages were noted by Jesuit explorers as early as 1698, and several short-lived forts were placed at the mouth of the Yazoo River as the area passed through French and Spanish hands.

The fort named Nogales by the Spanish was renamed Fort McHenry when the United States took over in 1798. A civilian settlement, Walnut Hills, had developed around the fort. When the first steamboats docked under the bluffs in 1812, Warren County's future was set. The next fifty years would see Vicksburg develop into ante-bellum Mississippi's most economically diverse town and the site of numerous notable houses.

Reverend Newitt Vick was a Methodist minister from Virginia who joined his brothers on the frontier of Jefferson County, Mississippi, in the early 1800s. He soon moved further north, building a church in the wilderness six miles east of the Mississippi at Open Woods. Reverend Vick quickly realized that economic as well as spiritual potential beckoned at Walnut Hills, and he began buying up land along the river; by 1819 he was selling lots and planning a city on the hills. A yellow fever outbreak that year claimed both the reverend and his wife, but their thirteen children survived to be key players in the earliest years of Warren County and the Delta.

Vick's son-in-law, John Lane, saw Newitt's town plan through and actually laid out the streets. In 1825, it was incorporated as Vicksburg. One of the town's first fine homes was built by another Vick son-in-law, Charles Kimball Marshall. Also a Methodist preacher, this Maine native stopped in Mississippi on his way to college in New Orleans and never left. He was renowned as a speaker, earning the nickname "the silver-tongued orator of Methodism." Religious pursuits were not his only concern; he accumulated extensive real estate in the developing city, adding to his wife's inheritance. Around 1830, he built the Greek Revival home that would come to be known as the VICK-MARSHALL HOUSE. Photos show a temple-style building, its six Ionic columns supporting a full entablature. Shaded galleries and floor-to-ceil-

Vick-Marshall House, built by "the silver-tongued orator of Methodism." Photo courtesy of Old Courthouse Museum, Vicksburg.

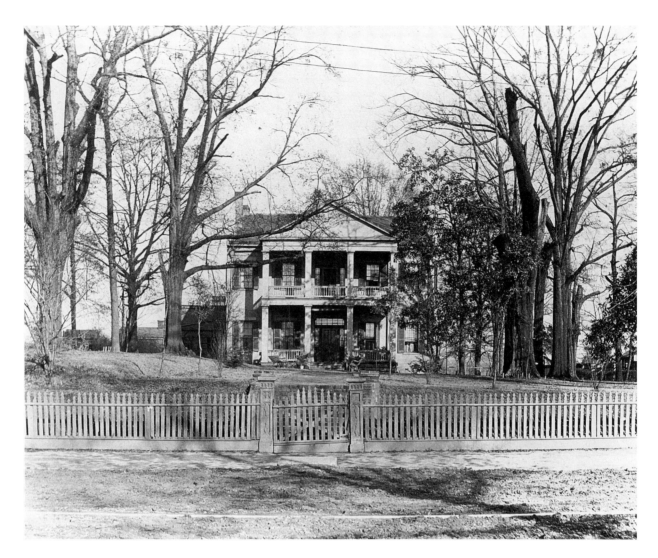

John Wesley Vick House, the Vicksburg home of one of the Delta's first planters. Photo courtesy of Old Courthouse Museum, Vicksburg.

ing windows are barely visible behind the tall columns. This house passed through several generations and families before being demolished in the 1980s.

John Wesley Vick was the second son of the Reverend Vick. Like his brothers, he was sent north for his education, studying at Transylvania University and Virginia. Returning to Mississippi, he bought several large plantations in the Delta, including Anguilla, and advanced cotton production with the development of a widely used strain of seed. In the Vick family tradition, he also acquired land around now-booming Vicksburg, eventually owning no fewer than twenty-nine lots. He chose to build his two-story Federal town house on Cherry Street. The four square columns of the JOHN WESLEY VICK HOUSE fronted upper and lower galleries, and a gabled roofline was outlined by four simple chimneys.

John Vick initially opposed secession, but wound up supplying the Confederate government with provisions. His Delta plantations were ransacked during the war, and his postwar request for reparations was repeatedly denied by the United States

The Castle, with tents of Federal troops scattered across the grounds. Photo courtesy of Old Courthouse Museum, Vicksburg.

government. By 1900, his house, outdated and unwanted, was torn down to make room for a Tudor Revival mansion.

By the 1840s, Newitt Vick's dream of a town on the bluffs had grown beyond anyone's most ambitious expectations. Planters from a hundred-mile radius flocked to Vicksburg to load their cotton on steamboats, and manufacturing diversified the healthy economic climate. Fortunes were being made, just as they were downriver in Natchez, and many newly rich townspeople chose to demonstrate their success in an architectural display. Greek Revival and Romantic styles would sweep the country in the decades before 1860, and Warren County was destined to be the site of some of their finest examples. It must have seemed to the citizens of the 1850s that they were building mansions for the ages, but many would be lost in the coming Civil War, the destructive fury of which seemed to peak at Vicksburg.

Unquestionably the most unusual antebellum house in Vicksburg was the C A S - T L E , an eccentric dwelling that lent its name to the hill at the end of Walnut Street. It was the creation of a local banker, Thomas E. Robins, who was notorious for settling disputes on the dueling field. Robins shipped in hexagonal bricks from England, perhaps hoping to lend some British authenticity to his re-created fortress. The Castle was a huge Gothic collection of battlements and parapets, and the whole structure was surrounded by a genuine moat. Seventeen acres of grounds were defined by a border of osage orange trees, and terraces led down to a man-made lake and walkways lined with statuary.

Robins was the son-in-law of Joseph Davis, and he was actively involved in the heated Democratic party politics of the mid-nineteenth-century South. The Warren County Democratic Association was organized within the walls of the Castle; signal guns fired from its ramparts in celebration of James K. Polk's 1844 presidential nomi-

nation startled the townspeople below. Robins moved back to his native New York in the late 1840s, dying there in an insane asylum in 1850.

The Castle was sold to Eilbeck Mason at public auction in 1852. Mason was a descendant of one of Virginia's first families and a brother-in-law of Robert E. Lee. His tenure at the Castle was somewhat calmer than that of the Robins family, and the home passed on to Armistead Burwell, another transplanted Virginia lawyer. Burwell was one of Warren County's most outspoken Unionists, inviting local hostility during the secession debates of 1860. His unflagging support for the Union cause won him no concessions from Federal troops in 1863; after breaking through Vicksburg's defenses, they camped in vast numbers on his lawn before destroying the house.

If the Castle was the height of architectural eccentricity, William Porterfield's S H A M R O C K was as traditionally southern a house as was ever built in Mississippi. Overwhelming in magnitude for downtown Vicksburg, its three full stories and monumental Tuscan columns dominated a corner for almost a century. This enormous brick edifice, like the Castle, took the brunt of Federal hostility during the Civil War. Shamrock did survive that conflict, only to crumble from sheer neglect.

William Porterfield was an Irish immigrant who tenaciously climbed Vicksburg's social and economic ladder after his arrival there in the 1830s. Hot-tempered and more than once brought up on assault charges, he made a fortune in steamboats, wharf property and insurance. A close friendship with the brothers Jefferson and Joseph Emory Davis led to his marriage to Joseph's adopted daughter, Julia. In 1851, he completed Vicksburg's largest mansion, naming it Shamrock in honor of his homeland. No expense was spared in its construction or dimensions:

> It [was] a large, square-built brick house, three stories high, with long, wide halls, three in number, two rooms on each side of the hall on each floor except the first; this has two on the right of the entrance and one, the banqueting hall, on the left, a room 24 x 42 feet, with ceiling 18 feet in height. It is lighted by 7 long windows; two of these windows open upon the street; two at the other end of the room open towards the river, looking across the beautiful grounds of the home. The floor of this splendid room is marble in alternate blocks of white and blue; two fireplaces, with mantels and jambs of carved white marble, attest the cheer that blazing fires once lent to festive occasions. . . . The interior finishing is of solid walnut, hand-carved. . . . The house has two fronts, the one towards the river commanding a view of the grand old river for miles down, and up to where the Yazoo pours its flood into the "Father of Waters."[1]

William and Julia Porterfield had only ten years to enjoy peace in their grand house; civil war and siege brought a quick end to the glory days of Shamrock. Towering above the rooftops of Vicksburg like the Old Courthouse, it presented an inviting target for bored gunners on the river, and the mistaken assumption that this must be General Pemberton's headquarters only worsened matters. Three weeks of shelling miraculously brought only one direct hit. That one shell flew through the open din-

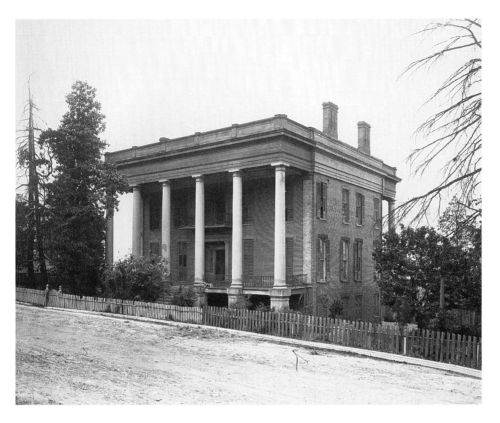

Shamrock, front elevation. A gunboat shell knocked off ceiling plaster and a corner of one of Shamrock's columns. Photo courtesy of Old Courthouse Museum, Vicksburg.

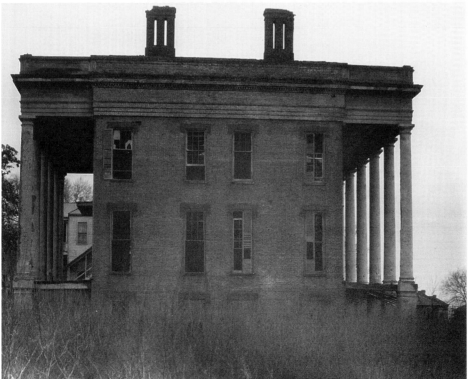

Shamrock, side elevation. By the 1930s, Shamrock was abandoned and crumbling. Photo courtesy of MDAH.

ing room door, scraped across the ceiling and into the parlor (knocking the facing off the door), exiting through the back doorway and clipping a chunk off one of the columns. With its dying momentum, it took the top off a cedar tree and thudded to earth.

Physical damage wasn't the only indignity suffered at Shamrock. By war's end, William had died of "apoplexy" and Julia was forced to rent out rooms to support their children. Joseph Emory Davis lived at Shamrock for a period after the war, firing off letters to Washington in a vain attempt to recover his wartime losses. Visitors commented on the unpainted plaster patches on the parlor wall, evidence of halfhearted attempts to repair the damage left from the shelling. Jefferson Davis would be honored with a reception at Shamrock on one of his infrequent visits to his former homeplace, but the house never again served as a gracious family home. Insurance maps of the early 1900s show its outline labeled as "lumber storage"; presumably, its vast spaces had been turned into a warehouse. WPA photos from 1934 show a corroding brick shell, its gardens long since given over to shacks and row houses. When Shamrock was torn down in the 1940s and the great columns were pulled to the ground, one still showed the chipped corner, a lingering reminder of the war that started the downhill slide of Vicksburg's finest house.

Rural Warren County was home to dozens of prosperous antebellum plantations. Most were planted in endless rows of cotton, but one operation near Bovina was unique for Mississippi. John Hebron, using his wife's inheritance to establish himself in Mississippi in 1834, acquired land east of Vicksburg and cultivated it with the usual cotton. The rich overflow topsoil near the Big Black River was ideal for that crop, but Hebron was more innovative than his fellow Deep South planters. He placed peach, pear and apple trees between the cotton rows, and, as they successfully took root and began to produce, the orchards gradually took precedence over the fiber crops. By the mid-1850s, Hebron had an orchard of twenty thousand trees; he shipped fruit throughout the Mississippi Valley and as far north as New York City, surpassing all other fruit growers in the South.

Hebron built a home, LaGrange, close to the orchards. An 1856 visitor described the house as being "constructed without reference to neatness or architectural effect."[2] That opinion notwithstanding, the Hinkle-Guild Building Catalogue shows a fine three-story residence with a raised basement and balanced side wings. No photos of the house exist to settle the dispute.

The results of John Hebron's years of hard work stood directly in the path of hostilities in 1863. Twenty-five hundred Union troops camped in his orchards as they laid siege to the river city. Hebron had died in 1862, and did not live to see General Grant use his house as a temporary headquarters. His youngest child exacted a measure of revenge for the intrusion; years later, this son would recall crawling on Grant's lap and pulling his whiskers, much to the delight of Mrs. Hebron. Relations were not so cordial out in the fields, where the trees were cut down and burned. The house was spared, but, after the war, the children dispersed and the house was abandoned. It was torn down in the late 1800s.

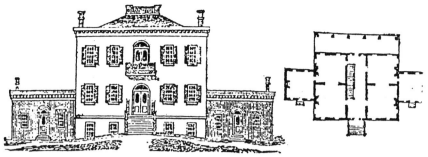

FIG. 26—88 feet Front, 50 feet Deep.

RESIDENCE OF JOHN HEBRON, LaGrange Nursery
Warren County, Miss.

LaGrange, as illustrated in 1860 Hinkle-Guild Building Catalogue. Reproduced with permission of MDAH.

Hyland House, abandoned and stripped of its silver doorknobs and solid walnut stair rail. Photo courtesy of MDAH.

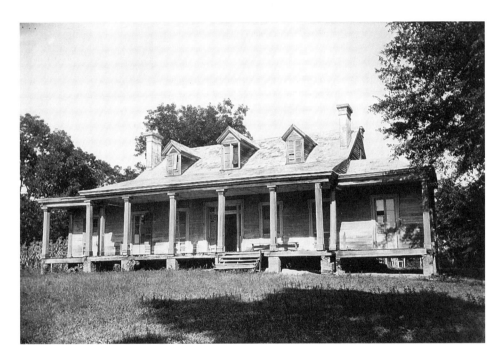

South of Vicksburg, in the Yokena community, Jacob Hyland brought Tory sentiments to the Mississippi territory after the American Revolution. He settled on land granted to him by the Spanish governor, Gayoso; over the years, two substantial log cabins were built on this land. The family prospered, but the future of the clan looked dim as one after another of Jacob's grandchildren died in childhood. Only one, William Steele Hyland, survived, becoming the sole heir to the now-extensive plantation.

William Hyland actually built the structure that came to be known as HYLAND HOUSE. It was a long, unadorned planter-style dwelling raised on brick piers, with simple square columns supporting the gallery and a dual-pitched roof with three dormers. Double front doors led to a central hall. From the rear of this hall an exceptionally steep stair extended to the upper floor. A solid piece of walnut was carved into a handrail for this stair. Sliding pocket doors separated the formal rooms, and an intri-

cately carved ceiling medallion in the parlor was a stark contrast to the overall simplicity of the house.

William Hyland died in 1868, and his daughter inherited Hyland House. It was rented to tenants and then abandoned altogether after World War I. Its highly visible location on a ridge overlooking Highway 61 and its decrepit state spawned numerous ghost stories and legends. Gradually, valuable elements like the walnut stair rail and silver doorknobs disappeared. The remains of the house were taken apart in the 1970s.

Although Warren County had more than its share of successful farmers, its most famous antebellum citizens were two "gentleman planters," lawyers by training, who built an empire at Davis Bend, twenty-five miles south of Vicksburg. This heavily wooded acreage, jutting into the current of the Mississippi River, was connected to the mainland only by a narrow neck of land. Joseph Emory Davis aquired several thousand acres of this rich Delta-like land in 1819. A practicing lawyer and member of the state's first constitutional convention, Joseph was pursuing his ambition of being a leisure-class planter, and to that effect he began clearing the briers and stumps from the wilderness of Davis Bend. By 1824, his progress was promising enough to make him feel secure about starting construction of a house befitting his status. Before it could be completed, a spring "cyclone" roared across the water from Louisiana, leveling the home. Undaunted, Joseph cleared away the rubble and began again. The finished house would be called, appropriately enough, Hurricane.

Hurricane was described by Joseph's sister-in-law, Varina Howell Davis, as an "odd-shaped, rambling pile," rising three stories above the river. The roof was "heavy" and punctuated by numerous sharp dormers. Galleries surrounded the main house on all levels, and the windows were noticeably small. The two main floors had four rooms each, all with unusually low ceilings for a southern house. A large annex, forty-three feet in length, stretched behind the house, housing the dining room and an upstairs music room. This room had an arched ceiling and walls lined with family portraits.

Several outbuildings complemented the main house at Hurricane. A brick structure housed the kitchen, laundry and servants' bedrooms. More impressive was the Garden Cottage, a temple-style building surrounded by Doric columns, used as a library, office and extra bedroom space. Surrounding this collection of buildings were gardens and fruit orchards. A long, circular drive led from the main house to the river landing. East of the complex, hundreds of acres of cane and briers were slowly being cleared, presenting a tempting vista to Joseph's youngest brother, Jefferson, when he visited in 1835.

Jefferson Davis had been raised in Wilkinson County, but by 1835 he had spent several years away from Mississippi. Weary of life in army posts, he brought his new bride, Sarah, to look at the land his brother was offering to him. The young couple decided to settle at Davis Bend, but before work could commence on a permanent house, Sarah died. Ten long years would pass before Jefferson married Varina Howell and began construction of Brierfield.

In that decade, Davis had concentrated on clearing his acreage at Davis Bend,

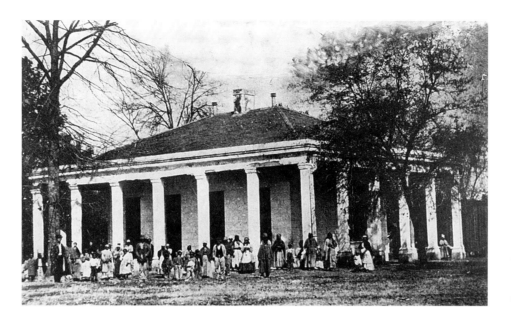

Hurricane Plantation, garden cottage. Joseph Davis's house was looted and burned by Federal troops, leaving only this structure. Photo courtesy of Old Courthouse Museum, Vicksburg.

while also becoming increasingly involved in Democratic politics. He was elected to Congress in 1845, but soon afterwards resigned the post and left for the Mexican War. His new wife, Varina, was left behind in the temporary house at Davis Bend, awaiting Davis's return in 1847. They began to implement plans for his long-delayed house, and contracts were negotiated in 1848. Varina recalled in later years that Jefferson "made a contract with Messrs. Marcy and Zeigler for a ten thousand dollar house, the heavy timbers to be cut on our own swamp land. A part, if not all of the framework came from Cincinnati and Vicksburg, I believe. This contract covered all except the filling up of the library and the purchase of marble mantel-pieces for the house."[3]

Finally finished in 1850, Brierfield was an extended single-story home raised only forty inches above the ground on its brick pillars. Spacious porches stretched the length of both the front and back facades, providing access and shade to the rooms along the way. The roof was shingled with hand-hewn cypress, covering a generous attic. The central portico and gallery were framed by identical wings, six fluted Doric columns supporting the central pediment and three smaller columns under the roofline of each wing. The overlapped cypress siding was painted white and complemented by green shutters.

Inside, a wide hall ran from the front door to the back, with two twenty-by-twenty-foot rooms to its immediate left and right. The front rooms were formal, serving as a parlor and a library; those in the rear were bedrooms. Opening off the twin thirty-four-foot porches were two more bedrooms, a dining room and study. Extending to the rear of the house was a brick wing with a kitchen and pantry connected to the main house by a service porch.

Locally abundant cypress provided the eight-inch sills resting on the foundation pillars and the floor joists. The columns, rather than being molded brick under stucco, were constructed of thick cypress blocks mitred together and held by wooden

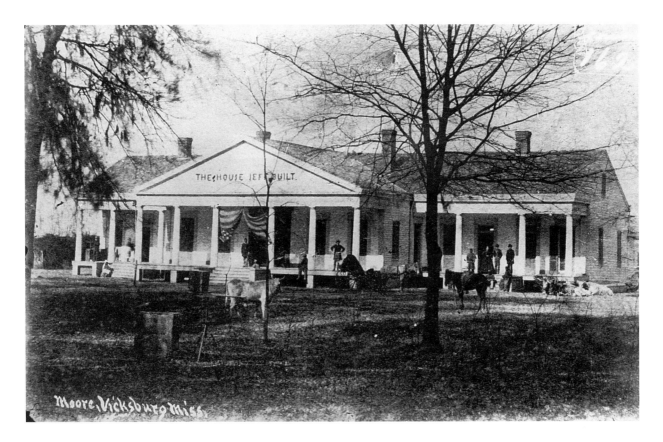

Brierfield, plantation home of Jefferson Davis, president of the Confederacy. Photo courtesy of Old Courthouse Museum, Vicksburg.

pins, then planed and shaped to give the round, fluted impression. The interior of Brierfield lacked the ornamentation so characteristic of this period. Door frames were functional without decoration, and there was a stark absence of molding and ceiling medallions. The walls, sixteen feet high, were simply plaster over lath, with no papering.

Beyond the main house, a variety of functional buildings served the plantation, including a steam-powered gin, a pigeonnier and a commissary. The roses that Jefferson Davis spent his spare time tending were entwined along yards of fencing that enclosed the house and the grounds.

Jefferson and Varina had but a handful of years at Brierfield. Davis, by necessity, spent more and more of his time travelling between Vicksburg and Washington as relations between North and South disintegrated. According to Varina's memory, she and Jefferson were tending their roses on a chilly day in February 1861, when a horseman galloped up to the house, bearing the news that Davis had been elected to the presidency of the fledgling Confederate States. Within twenty-four hours Davis was on a steamboat heading to Montgomery. Varina would follow the next week, and for all practical purposes their life at Brierfield was over.

Davis Bend was so remote that war took some time to reach it. In June 1862, Union soldiers landed on the peninsula and set about wrecking Hurricane. Thousands of books were piled into bonfires, china was shattered with gun barrels, and the ram-

bling old house was put to the torch. The flames were seen in Vicksburg, twenty-five miles away, throughout the night. Brierfield, for some reason, was spared, although it, too, was ransacked. After the fall of Vicksburg, Davis Bend was occupied by the Union army, eventually being turned over to the Freedman's Bureau. The land was sold to Ben Montgomery, a former Davis slave, and freed slaves farmed it until foreclosure returned it to Jefferson Davis's hands in 1881. By that time, the unpredictable Mississippi River had sliced through the levees on the eastern side, creating a new channel that effectively turned Davis Bend into Davis Island.

Jefferson Davis did not return to Brierfield until 1882, and he expressed no desire to live there again; he was within days of death when he again visited in 1889. From 1888 until 1916, Brierfield was occupied by a farm manager, its extra rooms converted into post office and school space for those few hardy souls still living on the island. Flooding had always been a problem, but the early years of the twentieth century saw the house repeatedly surrounded by muddy waters. In 1922, the currents rose halfway up the cypress columns, leaving the interior irreparably damaged. Davis's grandson had the entire structure jacked up on ten-foot pillars, and this effort kept the record-setting floods of 1927 beneath the house.

In March 1931, a chimney fire sent sparks onto the old cypress shingles, and howling spring winds quickly sent the blaze out of control. Photos taken several weeks later by Governor Dennis Murphree show an empty, blackened ruin, many of its interior walls gone. In the foreground of the picture, the fence so carefully tended by Jefferson Davis leans precariously, surrounded by encroaching briers and dirt. Six months after the fire, aerial photos showed only the brick foundation pillars remaining where Brierfield had stood. A small cabin was built on those pillars, but it burned a year later, almost as if this island refused to tolerate any more human interference. Davis Island became an isolated hunting preserve, its cropland largely reverted to forested wilderness. Those willing to brave a boat ride across the Mississippi and a treacherous hike across snake-infested brush can still find remnants of bricks and cisterns, scattered evidence of a lifestyle that vanished along with its builder's Lost Cause.

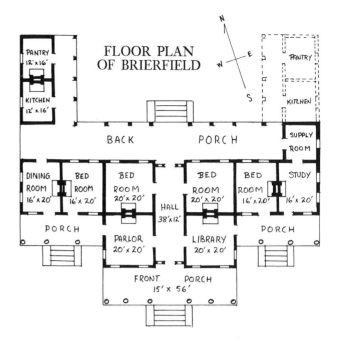

Brierfield, floor plan. Reproduced from Frank E. Everett, *Brierfield, Plantation Home of Jefferson Davis,* 1971.

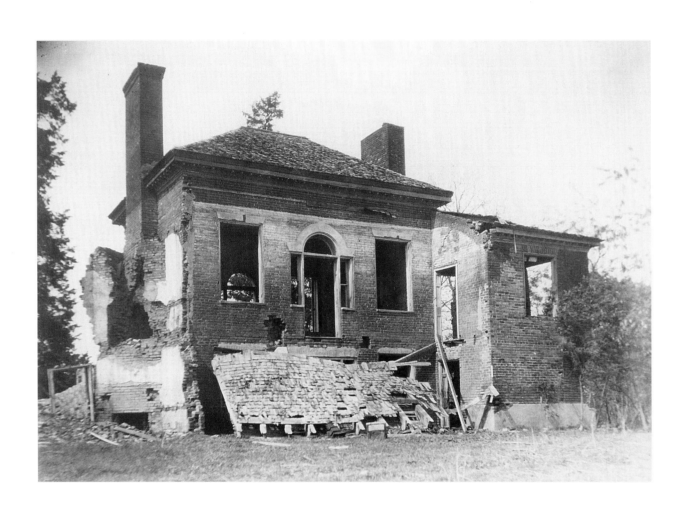

Hinds/Madison Counties

During Mississippi's territorial period, the rolling hills of the central section were home only to Indian tribes, and development was isolated and sparse. The Treaty of Doak's Stand, signed in 1820, opened 5.5 million acres of land for sale in this region. Two of the treaty's signers, Andrew Jackson and Thomas Hinds, would be honored with a namesake city and county, respectively. Towns began to appear rapidly as new landowners flocked in; some of those who arrived penniless would be cotton barons within a generation.

Three communities that trace their origins to this influx of new settlers developed along divergent paths: Jackson became the seat of government; Clinton, the center of education; and tiny Mannsdale would remain a farming center largely forgotten until late twentieth-century suburban development revived interest in its history. Each had its leading citizens, and they followed the predictable path of expressing their success in the size and design of their homes. Most of those houses were gone before photographers could record their images. The home of the territorial governor Cowles Mead, GREENWOOD, with its formal English gardens, was burned during the Civil War, leaving only the family cemetery northwest of Clinton. Governor William McWillie's mansion, KIRKWOOD, located near Sharon in northeast Madison County, was "a colonial pile with broad halls, large rooms, a conservatory, gardens and wide lawn. . . . After the death of Governor and Mrs. McWillie, their descendants felt that the old home's work was finished, and that it would better become a sweet memory and pass away with the master and mistress. . . . It was taken down, the carved woodwork of the library was given to a church, together with the handsome stair-rail. . . . Tall trees grow where once spacious halls and lofty rooms echoed."[1] Fortunately, not all of the area's houses were deemed "better . . . a sweet memory," and several of the more notable ones survived long enough to leave photographic documentation.

CLINTON owes its origins to Mississippi's third governor and first United States senator, Walter Leake. Leake chose land close to the Natchez Trace and to a spring noted for its healthful waters, naming his home MT. SALUS (Mountain of

Caldwell-Moss House. The house was in ruins when photographed by the Historic American Buildings Survey (HABS) in 1938. Photo courtesy of the Library of Congress.

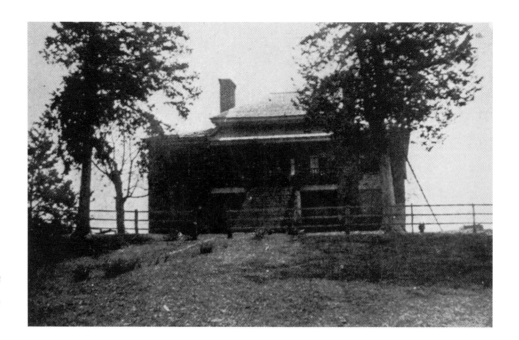

Caldwell-Moss House, site of a nineteenth-century murder. Photo courtesy of Shirley Faucette.

Health). The community that grew up around Leake's plantation took that name for its own, changing it to Clinton in 1828.

Governor Leake's Mt. Salus, reputedly the first brick house in Hinds County, was constructed in the formal English manor style. It sat high on the ridge running between Highway 80 and Interstate 20, an elevation that also provided the site of two other fine homes, the ROBINSON HOUSE and the CALDWELL-MOSS HOUSE. The Leake house burned in the 1920s and was replaced with a Colonial Revival structure, but the other two mansions' locations have disappeared beneath asphalt and modern development.

Colonel Raymond Robinson gave his name to the county seat south of Clinton. He was a well-respected citizen, more than could be said for his hot-tempered neighbor, Isaac Caldwell. Both of these gentlemen were remembered by two 1875 newspaper columnists who went by the pseudonyms "X and Y":

> Our earliest recollection of Colonel Robinson is that he was a widower, and had two charming daughters . . . Elizabeth and Lucy. . . . Elizabeth was married to Judge Isaac Caldwell. . . . Judge Caldwell came to Clinton about the year 1824, and was Circuit Judge in 1825. He was considered an able jurist for the time, was a very popular man—a chivalrous high-toned gentleman. . . . After his marriage to Miss Robinson, Judge Caldwell erected a splendid mansion about midway between Col. Robinson's and Governor Leake's residence, said to be the second oldest brick house in the county. The 'Caldwell House' was for years the pride of the village—the object of attraction to all—thought to be the 'finest house' in all the country, where he entertained in a sumptuous style. But this gifted man lived but a short time to enjoy the comforts of what promised to be a happy home.[2]

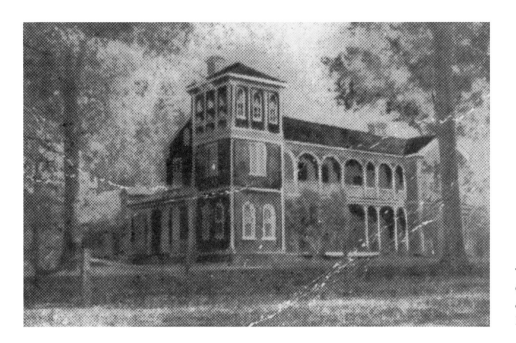

The Oaks, a long-lost Clinton mansion. Photo courtesy of Shirley Faucette.

Isaac Caldwell was a Kentucky lawyer, elected to the Mississippi Supreme Court soon after his arrival in 1825. His competency as a jurist is not recorded, but his temper and predilection for settling disputes on the dueling field have passed down through history. Caldwell's first challenge was to the legislator who cast the vote making Jackson rather than Clinton the state capital, and he escaped that episode without damage. He was not so lucky in his next confrontation, when he fought with Samuel Gwin after that gentleman insulted Caldwell's law partner. That 1836 match left Caldwell dead and Gwin seriously wounded.

Judge Caldwell's widow, Elizabeth, the daughter of neighbor Raymond Robinson, was left with the Caldwell mansion, built in the late 1820s or early 1830s. It was an H-shaped structure of brick, its two side wings connected by broad loggias on the front and rear elevations. Wide stairs arched over a raised basement level to reach the main floor. A large Federal-style fanlight graced the front door.

Mrs. Caldwell soon married a Judge Kearney from New York. Apparently possessing a temper to match that of his predecessor, Kearney murdered his new bride in an upstairs room of the Caldwell House. He fled to Mexico and was never prosecuted. Elizabeth was buried beside her first husband and her father in the family cemetery, a site that has been gradually surrounded by interstate highway construction and residential development. The Caldwell House later passed into the Moss family, and it was a crumbling ruin when photographers documented it in the late 1930s. Only the center section and one wing remained, the windows lacking panes and the fine front door long gone. The stairs were collapsed onto the ground, and the roof had nearly disappeared. The remnants of the Caldwell House were demolished soon after the picture was taken.

Clinton's status as a center of education was well established by the end of the nineteenth century. Mississippi College and Hillman College attracted hundreds of students from throughout the state and the South, and the yearbooks of those institutions are a storehouse of vintage Clinton pictures. One home featured prominently in several shots is identified only as the OAKS. Its arched verandas and square, three-story corner tower indicate a likely 1850s construction date, the heyday of such Italianate features. A large lake fronts the property. Sometime after the last photo of the house appeared in the 1907 Mississippi College annual, the house was lost and the lake filled in. Longtime Clintonians believe the site may have been close to Northside Drive, but modern development has obscured any trace of foundation or lake bed.

East of Clinton, JACKSON received its charter for success when it won that close 1829 election as capital city over Clinton. The basic plan for the city was laid out by Peter Van Dorn in 1822, and showed two perpendicular avenues leading away from a capitol green. Capitol Street was intended to serve the commercial needs of the town; North State Street would provide a broad thoroughfare for residential development. Indeed, Jackson's leaders did build their houses along North State for a century. At its peak, before commercialization began to creep in during the 1940s, North State Street boasted some of the South's finest homes along the mile between the Old Capitol and Millsaps College. Several predated the Civil War, with two of these being particularly notable.

One of the first large houses to be built on North State Street belonged to lawyer John Shaw. He was obviously prospering in the litigious atmosphere of a frontier capital; his house was a huge two-story Greek Revival structure of brick and stone, erected in the 1840s just north of High Street. This house survived when Jackson was reduced to "Chimneyville" in 1863, and it was sold to Colonel W. L. Nugent after the war. He added several rooms and the fluted Corinthian columns, altering the facade along the lines of the Neoclassic style popular in the 1890s and early 1900s. A crest-shaped window was centered in the massive formal pediment.

Colonel Nugent's daughter married Dr. Harley Shands, one of the founders of Baptist Hospital, and they lived in the grand mansion during North State's glory years. The NUGENT-SHANDS HOUSE was sold to the Jackson YMCA in 1949; finding it less than ideal for their purposes, the YMCA tore it down in the 1950s and replaced it with the building that later became First Baptist Church's Family Life Center.

One block north of the Nugent-Shands House stood a massive structure covering most of the 700 block of North State Street. It was the home of Tennessee native George Shall Yerger, one of nine brothers who had migrated to Mississippi to practice law. The YERGER HOUSE had fifteen rooms and was described in a 1902 article on Mississippi's most historic houses:

> The side veranda ornamented with heavy Corinthian columns presented a pleasing appearance; the heavy oak door rolled silently back and admitted to the spacious hall fur-

nished with handsome reception chairs and davenport, all elegantly furnished; the walls were adorned with figures of gorgeous birds of Paradise and peafowls painted in the richest colors of nature. On the left side of the hall were the double parlors carpeted with the richest velvet, and filled with carved rosewood furniture. . . . On this side of the hall there was also a large billiard room which afforded recreation to lovers of the game. The long dining room opened into an exquisite conservatory. . . . The first room on the right was a library lined from floor to ceiling with massive oak cases, filled with every line of literature, ancient and modern.[3]

Equally impressive were the Yerger estate grounds, with a goldfish-filled fountain and Moorish summer houses covered with rose vines.

Civil War scattered the large Yerger family. Following the death of George Yerger on a deer hunt, the Yerger House was sold in 1872 to the Deaf and Dumb Institute. That school's original building had been destroyed in the Civil War raids on Jackson, and the huge rooms of the Yerger House provided a suitable core for the new campus. Several classroom and dormitory wings were added over the years, but the original house was always evident as the center point of the complex. The entire building was destroyed by fire in 1902.

As Clinton and Jackson grew and prospered, the Big Black River lands to their north developed into a primarily agricultural region. Two of Madison County's finest houses were connected with one family and would supply a legacy that reads more like legend than history. Annandale and Ingleside survive as names of modern real estate developments. Mississippi Highway 463 winds through lands that were once part of those plantations, and where all evidence of their existence except for the Chapel of the Cross has been erased.

Yerger House, seen here as the central, columned section of the Mississippi School for the Deaf. Photo courtesy of MDAH.

Around 1820, three sons of North Carolina's surveyor general came to Mississippi to inspect the acreage opened up by Indian treaties. One of the three, John Johnstone, eventually bought twenty-five hundred acres near the MANNSDALE COMMUNITY. He returned to North Carolina to marry Margaret Thompson; she and their two daughters, Helen and Frances, stayed at the old homeplace while John travelled the long trails back and forth to Mississippi for fifteen years. He gradually moved his equipment, slaves and, in 1840, his family to Madison County. A large log cabin was their first home; it was known as Annandale in honor of the Johnstones' ancestral Scottish lands.

Soon after the Johnstones settled for good in Mannsdale, Frances married William Britton of Virginia. Understandably eager to keep his children close by, John presented the newlyweds with fourteen hundred prime acres of land east of Annandale. Near the present site of Madison, the Brittons would build INGLESIDE, a remarkably elegant Italianate home. Each of the eight bedrooms boasted a "dressing room" or closet, and the house also had a parlor, library, dining room, breakfast room and office. The formal rooms and four of the bedrooms opened off the main cross halls, while the remaining four bedrooms were divided in the two connected dependency wings. These sections were attached to the main body of the house by multiarched colonnades, and the whole facade was centered on a square tower incorporating the front door. To the rear of the main house, another wing stretched toward the separate

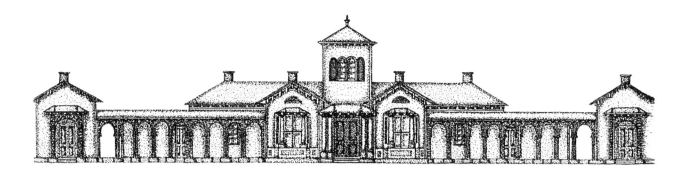

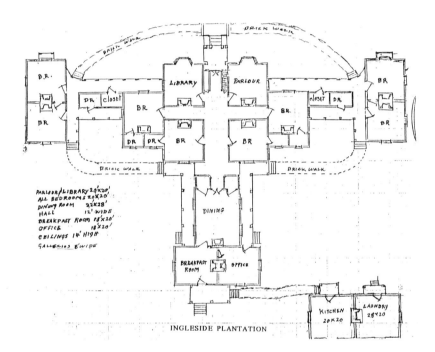

Ingleside, one of the Johnstone family houses in rural Madison County; here, Helen Johnstone met the ill-fated Henry Vick. Illustration by John Yerger.

Ingleside floor plan. Reproduced from Hugh Miller Thompson II, *The Johnstones of Annandale,* 1992.

kitchen and laundry room. Ingleside was described by Annandale's live-in tutor as "the most elegant establishment I've ever seen in the South."[4]

John and Margaret were not to be outdone by their daughter and son-in-law. They spent considerable time planning the construction of a chapel and home at Annandale, but John would not live to see the completion of either. He died suddenly in 1848, leaving a very determined widow to carry their plans forward. Margaret took over operation of the plantation and had the Episcopal Chapel of the Cross built in memory of her husband. It was consecrated in 1852.

Turning their attention toward erection of a suitable house, Margaret and her younger daughter, Helen, travelled the nation studying the latest architectural styles. Rejecting the prevailing mania for Greek Revival, Margaret selected a plan for "Villa No. 4" in Minard Lafever's *Architectural Instructor,* a popular pattern book of the day. Master builder Jacob Larmour was engaged for the job, millwork was ordered from

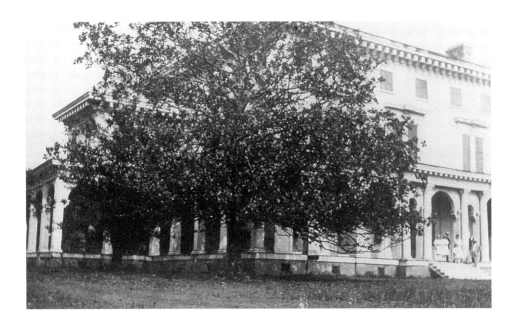

Annandale, front eleva-
tion, one of Mississippi's
grandest Italianate houses.
Photo courtesy of Gay
Yerger.

Hinkle, Guild of Cincinnati, and the forty-room, three-story mansion known as
ANNANDALE began to rise above the rolling fields of Madison County.

Annandale's construction took a full three years, and Margaret and Helen moved
in during 1859. Hugh Miller Thompson II, a Johnstone descendant, described the fin-
ished house:

> The completed product contained forty finished rooms on three floors. Only two rooms
> were finished on the third floor. No expense was spared in decorating the mansion. The
> plaster work was done by special artisans and the cornice moldings were deep and ornately
> designed. The plaster medallions on the ceilings matched the cornice mold and bronze and
> crystal chandeliers hung from the center. Ceilings on the first floor were sixteen feet high,
> fourteen feet high on the second floor, and twelve feet on the third floor. The great hall was
> entered through massive double doors with an enormous fan-light transom above. Floors
> were of tongue-and-grooved oak, six inches wide by two inches thick. The chandeliers were
> lit by gas that was manufactured from a coal pit on the plantation. Running water was sup-
> plied from a copper tank on the third floor that was kept pumped full daily. The main
> rooms in the house were twenty-four feet wide and of varying lengths. The great hall was
> twenty-four feet wide by about eighty feet in length. At the end of this hall a staircase rose
> to a landing and then branched out to the right and left to ascend to the second floor. The
> fact that the end of the hall was circular made the branching staircase spiral in appearance.
> In the back hall was an unusual feature—a dumb waiter that was so intricately balanced
> that heavy containers of fuel and other materials destined for the second floor could be
> raised with little effort. The dining room, located at the rear of the hall, had rounded cor-
> ners. In each corner adjacent to the fireplace were niches that contained statuary. The entire
> house was built of long leaf pine and cypress and would, I am sure, be standing and in
> excellent condition today if it had not burned on September 9, 1924. One very unusual fea-
> ture of the house was the beautifully carved marble mantelpieces at all fireplaces. These

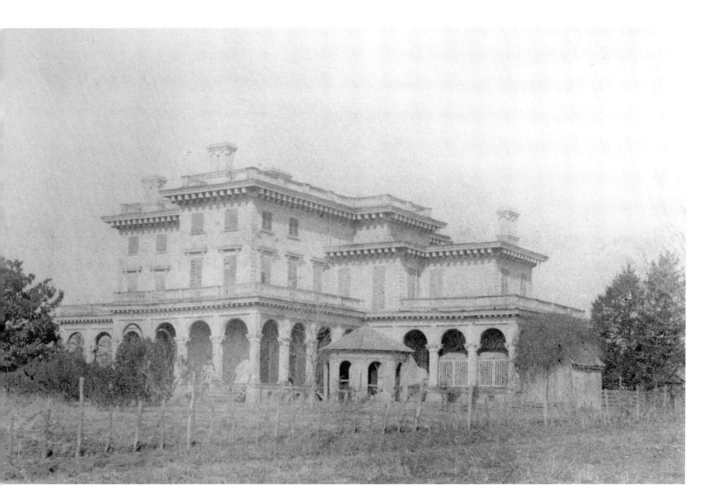

mantels were imported from Europe. Another item of note was the heavy gold-leafed valances over the parlor windows that were attached permanently to the wall and remained there after the house was sold. The carpets were manufactured to order in France to fit the double parlors and library. As was the custom in those days the kitchen was built separate from the house.[5]

The exterior of Annandale was exuberantly Italianate, unlike anything else ever built in Mississippi. Its three-story central block featured rounded-arch, rectangular and square windows on successive levels. Multiple arches ran the length of the galleries, and heavy modillion brackets underlay the eaves.

Life for those at Ingleside and Annandale was typical of country gentry, but the tranquility was soon shattered by tragedy, giving rise to the story of "the bride of Annandale." Young Helen met Henry Grey Vick, great-nephew of Vicksburg's founder, when his carriage broke down near Ingleside. They were soon engaged, with a wedding date set for Helen's twenty-first birthday, May 21, 1859. Annandale's finishing touches were being hurried into place and frenzied preparations were underway for Madison County's premier social event. Henry left for a quick business trip to New Orleans, promising Helen that he would always avoid the prevailing tradition of

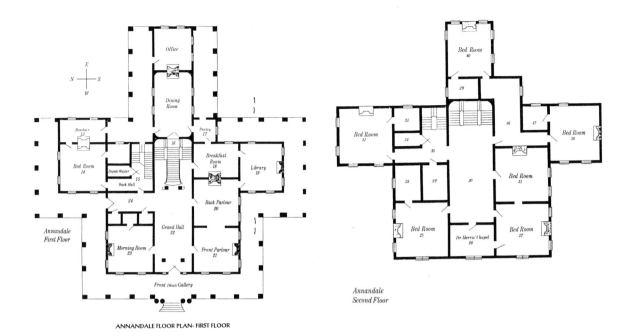

ANNANDALE FLOOR PLAN- FIRST FLOOR

Annandale floor plan, first floor. Reproduced from Hugh Miller Thompson II, *The Johnstones of Annandale*, 1992.

Annandale floor plan, second floor. Reproduced from Hugh Miller Thompson II, *The Johnstones of Annandale*, 1992.

dueling over the slightest insult. Despite his best intentions, he became involved in a dispute over land with an old acquaintance, James Stith. Tempers flared, words were exchanged and Stith demanded a duel in Mobile. Vick, honor bound by the day's standards, reluctantly headed for Alabama, first making out a will in which he left his possessions to Helen. As he and Stith faced off on the dueling field, Vick fired his gun into the air and was killed instantly when Stith's bullet struck him in the head.

Back in Madison County, the unsuspecting Mrs. Johnstone and Helen were arranging parlor decorations at Ingleside when a telegram arrived by messenger: "Henry Vick killed today May 17 in a duel at Mobile, Alabama. Will bring body to Vicksburg on earliest steamer." The family, plunged from the emotional high of wedding preparations into an inconsolable mourning, was forced to wait for Henry's body to be brought from the landing at Vicksburg. The funeral cortege arrived near midnight on the eve of what would have been the wedding day. The torchlight procession wound through old Mannsdale to the Chapel of the Cross, and Henry was buried there.

The gloom at Annandale was intensified by escalating threats of war, which burst into reality in 1861. True to her nature, Margaret Johnstone stood fast on her plantation, organizing the Livingston Ladies Military Aid Association at Annandale. Helen had fine gray uniforms fitted for a local troop who would go through the war as the Helen Johnstone Guards. Annandale and Ingleside were never seriously threatened by the devastating events in neighboring Hinds and Warren counties, but Reconstruction brought change to every corner. William Britton feared for the future of Ingleside in those uncertain times and sold the plantation, moving his family to Pass Christian. There he built another fine house facing the Gulf of Mexico. After his death in 1871,

the family moved back to Madison County; finding Ingleside in disrepair and the new owners remiss in their payments, they immediately repossessed it and restored it to its proper state.

The Britton descendants lived in Ingleside until 1906. On a spring day of that year, the old nemesis of Mississippi's mansions caught up with the historic home. Hugh Thompson remembered the loss: "The fire happened one day about noon while the plantation hands were bringing in the mules for feeding. At the same time there were several men working on the construction of a new barn. Therefore, when the fire broke out, immediately there were a number of people at the scene. They tried to extinguish the fire, but it had gone too far. . . . The house was a structure about one hundred eighty feet wide and the fire had started in the extreme south wing. Fortunately, a great portion of the furniture was moved from the house by the large number of people present. The house burned completely in two hours."[6]

A similiar house was soon built on the foundations of the first Ingleside, but it never approached the magnificence of the original. Hard times and neglect led to foreclosure, and the second Ingleside slowly collapsed. The walls of the dining room provided enough lumber to build an enormous barn, which stood on the old plantation land for years. When the structure was finally torn down, it yielded the original hinges and doorknobs from Ingleside.

Times had changed at Annandale. Matriarch Margaret had died there in 1880, and Helen had married Episcopal priest George Carroll Harris, relocating with him in Memphis and Rolling Fork. Annandale was sold to a Mr. Hartfield, and it was unoccupied when it burned on that September night in 1924. Only the Chapel of the Cross, still in use, remains to memorialize the remarkable Johnstone family and the legendary "Bride of Annandale."

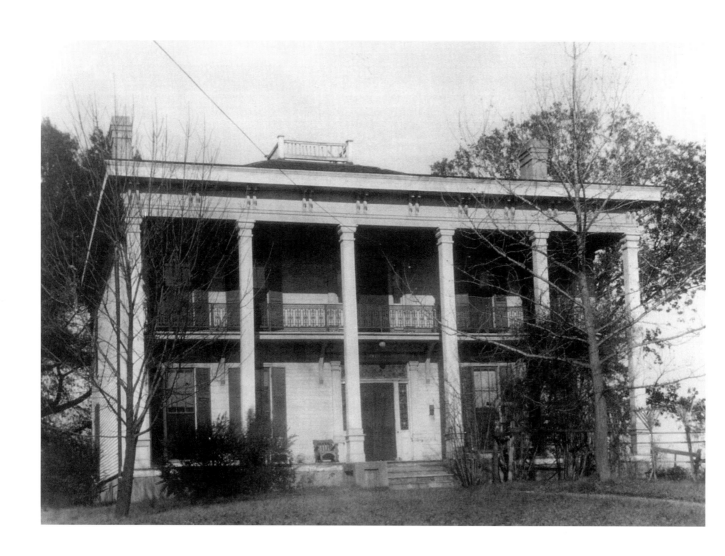

North Central Mississippi

After the Choctaw and Chickasaw tribes signed over their lands to the government in a series of treaties in the 1820s and 1830s, millions of undeveloped acres were suddenly available. Farmers and plantation owners in the Carolinas, Georgia and Virginia, struggling with the rapidly dwindling fertility of their own soil, saw Mississippi as the Promised Land. By the thousands, settlers and speculators poured into north and central Mississippi, staking their claims on the old Indian lands. Hamlets emerged on river banks and ridges, often disappearing within a generation as other towns became dominant. Those settlements designated as county seats or lying close to the new railroad lines grew and prospered, and by the 1840s leading citizens were building homes to reflect their wealth.

OXFORD started as a crossroads trading post in 1835; it was well situated to capitalize on the needs of new farmers planting the lands along the Tallahatchie River. Business boomed, and Oxford's future was secured when it was awarded both the Lafayette County Courthouse and the University of Mississippi. Several smaller towns along the river dried up, and Oxford's architectural legacy began to evolve. In 1852, enough construction was under way to warrant newspaper advertising by several "professional architects."

One interesting character who appeared in Oxford was Tomlin Avant, the youngest son of a Virginia planter. History doesn't record the circumstances that led him from gentrified Virginia to rough-and-tumble 1838 Mississippi; he arrived without a cent and proceeded to marry the daughter of a leading citizen. Promising her a house in keeping with his newfound social standing, Avant borrowed heavily for the construction of the BRIDE'S HOUSE. This Greek Revival edifice on College Hill Road was one of Oxford's first grand mansions. Six square columns rose to a bracketed cornice, and wrought-iron balustrades enclosed the second-floor balcony. The hipped roof sported a widow's walk and twin chimneys.

Avant was a blatant opportunist, even by the loose standards of antebellum Mississippi. He not only borrowed heavily from his fellow townspeople to build his man-

Bride's House, Avant-Stone House. Struggling writer William Faulkner found encouragement and a place to store his unsold books here. Photo courtesy of MDAH.

sion, but also added an overseer's house and a smaller columned house next to the Bride's House to attract, as he phrased it, "neighbors worthy of him." Twenty-four hours after the last wagonload of lumber was delivered, he declared bankruptcy, leaving his creditors empty-handed and furious. Avant kept the Bride's House, shamelessly entertaining on a lavish scale, with orchestras imported from Memphis and New Orleans. When Union General Whiskey Smith's troops burned Oxford, Avant fled, leaving his wife to deal with Federal occupation of the house. She convinced them to spare it, but Avant finally lost it in postwar lawsuits. He died heavily in debt, reduced to living in the overseer's cottage.

The Avant House passed into the hands of Edward Mayes, son-in-law of Supreme Court Justice L.Q.C. Lamar. Mayes was a professor and chancellor at Ole Miss, and he likely built the floor-to-ceiling bookshelves that lined the upstairs hall of the house. When he moved from Oxford in 1891, he inexplicably left behind hundreds of leather-bound volumes. The house sat empty for a year, gathering dust and a reputation for mystery. When James Stone of Batesville bought the property, he was warned to expect ghostly company. Undeterred by his neighbors' superstitions, he moved his family into the house in 1892.

Stone was a Kentucky-educated lawyer who would rise to the presidency of the Bank of Oxford, but his most lasting fame came from being the father of Phil Stone. Young Phil took time to read and critique the earliest writings of William Faulkner, spending hours with the struggling poet and novelist among the upstairs bookshelves. When dozens of copies of Faulkner's *Marble Faun* were returned unsold, Stone stored them in the house, along with manuscripts of other early Faulkner works. Unfortunately, this literary gold mine was in the Avant-Stone house in January 1942, on a night when the temperature plunged to three degrees. Fires were roaring in every fireplace in a vain attempt to heat the high-ceilinged old mansion. A defective chimney allowed flames into the walls, and the house quickly became an inferno. Fire hoses froze and burst as neighbors pitched in to salvage what they could, passing furniture out the front door. A breakfront was carried onto the lawn without a piece of china being chipped. Smoke and heat blocked access to the upstairs library; hundreds of priceless books were lost, along with Faulkner's manuscripts and valuable first editions.

Northwest of Oxford, Como grew up along the railroad that cut a path through Dr. George Tait's plantation in the 1850s. Growing into a sizable town in the last years before the Civil War, Como was graced with an unusually large number of exceptional houses. One of these belonged to Dr. Tait, an early settler in the area, who asked the townspeople to name their community after his favorite Italian resort rather than in his honor. No photos survive showing the TAIT HOUSE, but its later years were described in Stark Young's memoir, *The Pavilion*:

Next to Uncle Hugh's was what was known as the Tait House, a fine place that had seven halls and on three sides porches in the Palladian manner with columns. It had been built by

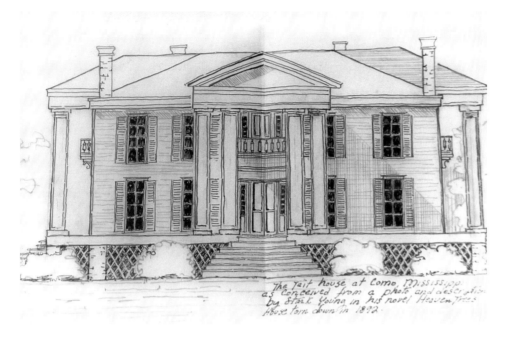

The Tait house at Como, Mississippi as conceived from a photo and description by Stark Young in his novel *Heaven Trees*. House torn down in 1892.

The Tait House, immortalized in Stark Young's *The Pavilion*. Illustration by Ruffin Sledge Davis.

Dr. George Tait. . . . The house [was] emptied of its furnishings; the brocades from the curtains, the books from the library, the silver and china, nobody knew where they had gone. Uncle George had a diploma from some university to practice medicine, but his plantations had made that unnecessary, and the number of kin and family connections, from whom no fee could be collected, made it futile, so that he soon forgot his saddle-bags and devoted himself to books and whiskey. The place was haunted with the ghosts of happy elegance and the drunken sprees and sorrow, pranks after the school of the frontier, gardens, celebrations and the whole sarcasm of past time.[1]

The Tait House burned in 1892.

HOLLYWOOD, several miles east of Como, was built in the 1850s by John Scott McGehee to serve as a wedding present for his daughter Ann. Ann McGehee Dandridge enjoyed a classic Greek Revival house, surrounded by trees, its huge columns rising from square concrete bases. Broad steps led to the porch with a small balcony above. No other descriptions of the house have survived, but photos show a pastoral setting in a shaded lawn. The most memorable legend of Hollywood tells of Ann Dandridge's trek across war-ravaged Mississippi in 1862 to retrieve the body of her son, who was killed at Shiloh. He was buried in the cemetery at Fredonia Church, a structure still standing in rural Panola County. Reconstruction devastated the McGehee and Dandridge families, forcing them to seek opportunities elsewhere. Hollywood burned in the 1890s.

The grand houses of Como were built facing the railroad tracks that split the residential and business sides of town. One of the most unusual was the NORFLEET RUFFIN SLEDGE HOUSE, dating from the mid-1850s. This was a tall, center-gabled house featuring panelled columns that were wide on the ground level and

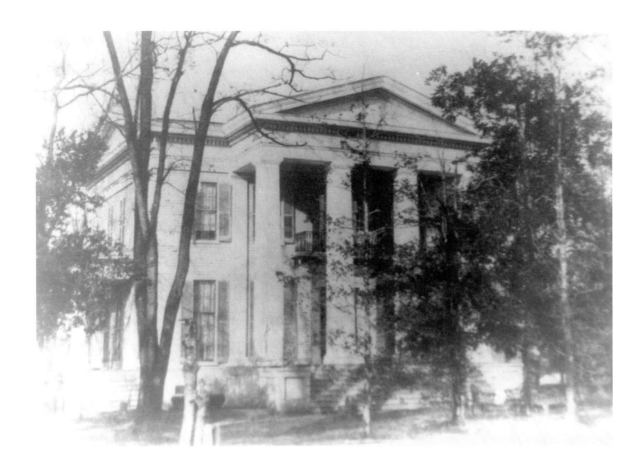

Hollywood, a short-lived mansion east of Como. Photo courtesy of Ruffin Sledge Davis.

Norfleet Ruffin Sledge House. The ornamental iron stairs were shipped from New Orleans to Memphis by boat, then hauled south to Como. Illustration by Ruffin Sledge Davis.

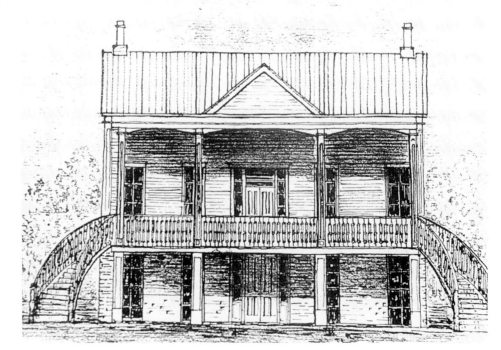

more delicate on the upper level. Ornamental iron stairs, having been cast in New Orleans, shipped upriver and carried overland from Memphis to Como, curved from the basement to a full-length veranda. The Norfleet Ruffin Sledge House was destroyed by fire in 1980.

Further south, two competing towns grew up near the Yalobusha River in the 1830s. Persistent feuding stifled the growth of both Pittsburg and Tullahoma; their differences were finally ironed out in 1836, when the two merged to create G R E N A - D A . Ireland native Robert Mullin arrived in the nearby hamlet of Troy during this period and set up a tailoring business. Soon he was more involved in shipping cotton than in mending clothes, and his fortunes grew along with Grenada.

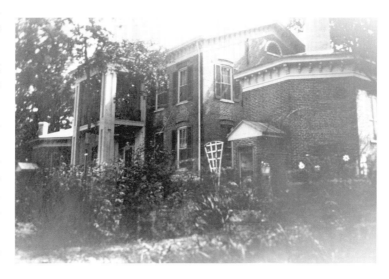

Mullin hired a local carpenter, John Moore, to design and build his home, E V E R G R E E N . Its brick construction and fine detailing were extraordinary for the time and place. Two-story, with two flanking windows on either side of the upper and lower doors, it was topped with a tin-sheathed gable roof. The cornice was wood-bracketed plaster, and matching central porticoes graced the east and west facades. The doorways were framed with transoms and sidelights, and the segmental-arched windows were capped with corbeled crowns. Louvered shutters hung at each window, and an iron-railed balcony fronted the upper doorways on both primary facades.

Evergreen, front elevation. The house was flanked by unusual twin octagonal dependencies. Photo courtesy of Louise Meek.

The most unusual features of Evergreen were the twin brick octagonal dependencies immediately to the north and south of the main house, each reflecting the design of the house with their tin roofs and bracketed cornices. Two more dependencies, containing two rooms apiece, faced each other behind the house. Latticed well houses and iron gazebos were also part of the original grounds. The interior plan of Evergreen was uncomplicated; it was two rooms deep on either side of a central hall. Its millwork can be traced to an 1860s Cincinnati supply catalogue as the source of its Greek Revival architraves, pilasters and ceiling moldings.

Robert Mullin emerged as one of the leading citizens of early Grenada, surviving the Civil War, a disastrous 1884 downtown fire and an 1878 yellow fever epidemic, which took the lives of several hundred Grenadians. Evergreen fell into disrepair after he built a smaller house nearby, but his granddaughter restored the big house and raised her family there. In the twentieth century, it passed out of the Mullin family, and it was undergoing restoration when it burned in the 1980s.

West and south of Grenada, C A R R O L L C O U N T Y enjoyed the antebellum prosperity brought by the cultivation of the rich Delta lands on its western edge.

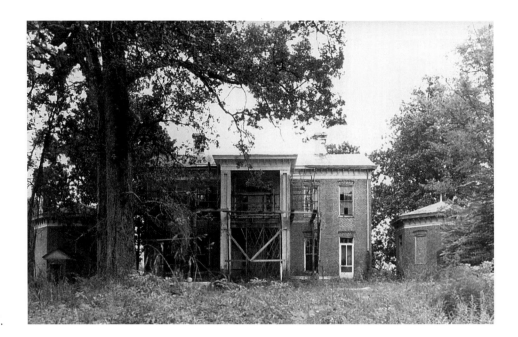

Evergreen, under restoration. A fire during the restoration totally destroyed the house. Photo courtesy of MDAH.

Planters were reluctant to move their families into the mosquito-infested flatlands, so they built their fine homes in the foothills near Carrollton and Vaiden. A young architect from Georgia, James Clark Harris, would be responsible for building two homes that would rival the finest mansions of Natchez or Columbus. Both stood for a century, with one being lost to fire and the other to abandonment.

PRAIRIE MONT was the home of Dr. Cowles Mead Vaiden, a Virginia native who bought up vast tracts of land in Mississippi. His three-thousand-acre plantation was east of the tiny Shongalo community in Carroll County. When the railroad was laid down a few miles west of Shongalo, the entire town packed up and moved, naming the new town Vaiden after its most prominent citizen.

Dr. Vaiden commissioned James Clark Harris to design and build a house suitable to his lofty status. Considering the fact that, in the 1840s, Carroll County was a sparsely settled spot hundreds of miles from Mississippi's cultural centers, Harris's finished product was remarkable. Set high on a rise overlooking Vaiden's farmland, Prairie Mont was a blend of Greek Revival and Italianate styles. The frame structure was fronted by a two-story central portico. Ionic columns were paired, rising to support a bracketed cornice and roofline balustrade. The bracketing encircled the entire roofline, and it was echoed under the eaves of the square cupola. The horizontal wood siding was wider under the portico, accentuating this facade. Four six-over-six shuttered windows flanked the Greek Revival entranceway, and two round-arched windows allowed light into each side of the square cupola.

The interior of Prairie Mont was as striking as the exterior. The first floor included seven spacious rooms and cross halls, one of which held a winding stair leading to the five rooms on the second floor. The spiral stair continued up to the attic level, where one windowless room was referred to as the "dark room"; here Dr. Vaiden kept his

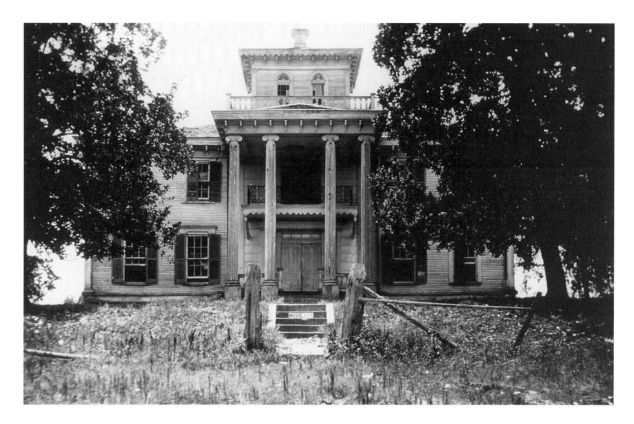

stores of whiskey. Another stair led upwards to the observatory, where the arched windows were tinted different colors to represent the four seasons. Marble mantels and painted murals decorated the walls throughout.

Dr. Vaiden was, by all accounts, a civic-minded public servant as well as Vaiden's richest citizen. He was elected to the legislature and sat on the board of trustees of the University of Mississippi. But even the most noble of individuals has an occasional lapse into self-aggrandizement: Dr. Vaiden's was a ten-thousand-dollar life-size statue of himself, which he had commissioned for his own grave. Carved in Italy, it was barely saved from the waters of the Atlantic when its transport ship sank. At Vaiden's burial in 1870, the statue stood over the gravesite, but the service's dignity was shattered when most of the mourners left to give chase to a horse thief.

Dr. and Mrs. Vaiden died childless, and their adopted nieces and nephews likewise had no heirs. The house passed through several other owners in the ninety years following Dr. Vaiden's death, but maintenance gradually declined. WPA photographs from the 1930s show Prairie Mont still standing, but with peeling paint and sagging shutters. A 1950 visitor described a sad sight: "You will see how woodpeckers have drilled holes for droning bees to swarm into four tall columns. Broken window panes stare at you vacantly. You can hear the drip of a leaking roof into a battery of pots and mason jars. . . . You can see where the imported Italian marble mantels have been ripped from the walls, and a fresco medallion in the twelve-foot ceiling shows where sparkling chandeliers once hung."[2]

Prairie Mont, home of Dr. Cowles Mead Vaiden. This Italianate showplace had deteriorated to an uninhabitable state by the 1950s. Photo courtesy of MDAH.

Prairie Mont's fine panelled doors were used to build a storage shed on the site. Photo courtesy of Frances Welch.

Prairie Mont was never restored. Dangerously dilapidated, it was torn down in the late 1950s. Standing on the site now is a utility shack, fashioned entirely from the fine panelled doors that once graced the Vaiden house.

On the crest of the westernmost hill in Carroll County, Choctaw chieftain Greenwood Leflore had James Harris build his palace, MALMAISON. It was similar in many respects to Prairie Mont, which Leflore had no doubt admired. Once again, Harris blended Greek Revival and Italianate elements to create a unique mansion, this one overlooking Leflore's fifteen-thousand-acre plantation, Teoc. By the time it was completed, around 1854, Harris had married Leflore's daughter, Rebecca, and their descendants would be among those who occupied Malmaison for the century that it stood high above the Delta.

Greenwood Leflore was born into what passed as aristocracy in frontier Mississippi. His father, Louis LeFleur, founded the trading post that would grow into Jackson, and Greenwood spent most of his youth at French Camp, constantly reminded of his one-quarter-Choctaw heritage and his family's high standing in that tribe. A frequent visitor to the family stand at French Camp was Major Donley, the holder of the mail contract for the Natchez Trace. An educated man, Donley recognized Greenwood's leadership potential and convinced the boy's father to allow him to be raised in Nashville. Greenwood lived with the Donley family for several years and eventually married Major Donley's daughter. He returned to Mississippi and was elected chief of the Choctaw tribe in 1824, representing his people at the signing of the Treaty of Dancing Rabbit Creek in 1830. The Choctaws' land was surrendered and the tribe was sent west to Oklahoma territory. Leflore came out of the arrangement with the nucleus of an agricultural empire that would eventually encompass one of Mississippi's largest plantations.

This chief-without-a-tribe chose a towering hill on the edge of the Delta to build his home; for twenty years, he raised his family in a modest log house, but his dreams were expanding right along with his land holdings. By the mid-1850s, he and James Harris had plans in hand for Malmaison. Hundreds of tall pines and cypress trees were felled, their wood left to season for a year before being planed. No expense was spared in construction or details as the huge house emerged from the wilds of Carroll County.

Malmaison was predominately Greek Revival in style, with porticoes fronting each entrance of the main house. As at Prairie Mont, each portico had paired square columns, rising to bracketed cornices that carried on to the main roofline. Pilasters were spaced between the windows, and a hipped roof led up to the home's crowning glory, a double-decked cupola and balustraded promenade, soaring so high above the Delta that it was visible for miles.

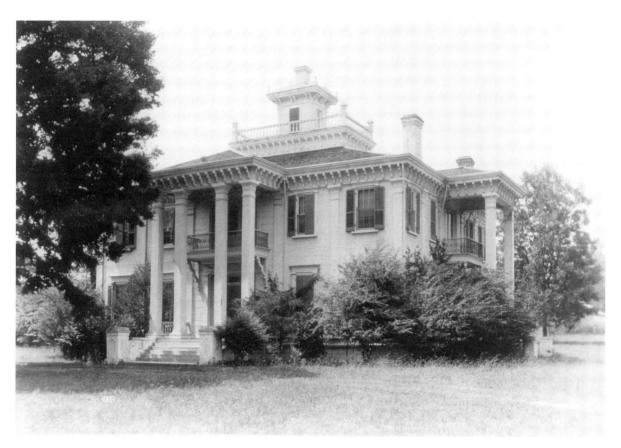

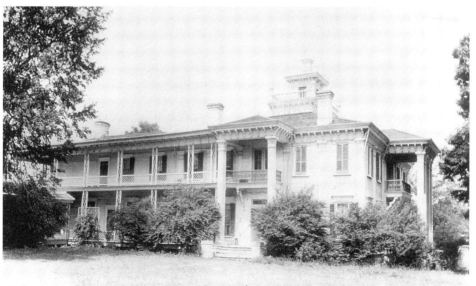

Malmaison, front elevation. Greenwood Leflore flew the American flag from the cupola throughout the Civil War. Photo courtesy of MDAH.

Malmaison, side elevation. Photo courtesy of MDAH.

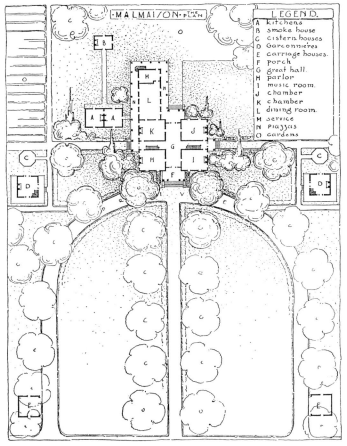

The Plan

MALMAISON, CARROLL COUNTY, MISSISSIPPI

A Southerner never lost sight of the fact that he had plenty of space and that scale demanded he use it. Here we see a plantation group entirely covering a hilltop, overlooking an extensive valley.

Malmaison, plan of house and grounds. Reproduced from J. Frazer Smith, *White Pillars: The Architecture of the South*, 1941.

The floor plan showed a series of long hallways intersecting in a Greek cross pattern, the north-south hall stretching fifty feet; its east-west counterpart ran a seemingly endless sixty-five feet. Fifteen rooms were decorated by French and English craftsmen well versed in plaster ornamentation and molding. Eleven black marble mantels were shipped from Europe, along with ten thousand dollars worth of hickory parlor furniture. Aubusson carpets covered the floors, and silk damask window shades were hand-painted with scenes of Versailles, Fountainbleu, St. Cloud and the original Malmaison of Empress Josephine. Hanging above the mantels were oil portraits of Greenwood Leflore and Pushmataha, along with a ceremonial sword and belt presented to the chieftain by Andrew Jackson. The dining hall, contained in a rear wing connected to the main house, was sixty feet long and the scene of many formal banquets.

Greenwood Leflore died in 1865, remaining a staunch Union sympathizer throughout the Civil War. The American flag flew from the cupola of Malmaison for those four long years, enraging local citizens and resulting in several attempts at arson. The home remained in the Leflore family, well maintained and a source of pride, unlike the fading Prairie Mont. On an October night in 1942, two of Leflore's granddaughters spending a quiet night at the house were startled by the sound of crashes in the attic. A fire had somehow started in the upper portion of the house, and the century-old cedar timbers were falling. By the time help arrived, the great mansion was engulfed in flames, and the women were frantically pulling brocaded furniture across the porches. Leflore's carriage was rushed from the stable and saved, but the main house was a total loss. For years afterwards, the Italianate outbuildings served to mark the location of Greenwood Leflore's empire, but eventually neglect claimed those buildings also. Kudzu has crept over the foundations and cisterns, hiding any trace of Malmaison from all but the most determined searcher.

Holly Springs

The economic and architectural development of Natchez, Vicksburg and Port Gibson spanned decades; in contrast, Holly Springs emerged practically overnight from the wilderness of 1830s north Mississippi. Situated in Indian territory opened for sale by the 1832 Treaty of Pontotoc, this tavern stop quickly grew into a bustling community that attracted not only pioneers and land speculators but also established families of the Carolinas and Georgia. As the Atlantic Coast states' soil thinned from years of growing cotton and tobacco, wealthy planters sent their sons to the last significant block of land available in the old Southwest. They brought their servants and traditions with them, and proceeded to build fine houses instead of dogtrots. Holly Springs's early society benefitted from escalating cotton prices, a bustling iron foundry and frenzied land speculation. By 1838, the square boasted fourteen law offices, six doctors and two banks. The Marshall County Courthouse was being completed, and the young city ranked behind only Natchez and Vicksburg in population among Mississippi towns.

The first imposing residence to be built in Holly Springs was likely that of William Mason. Finished in 1840, it has been described as an I-house (two rooms wide and one room deep) with Greek Revival detailings. When the cotton market collapsed that year, the building boom slowed, but the later years of the decade brought another wave of flush times, and the great houses of Holly Springs began to emerge in the 1850s. Jones and McIlwaine Foundry provided the intricate ironwork on many of the homes, and cotton prices fed the escalating dreams of the town's elite. The Greek Revival showplaces of Holly Springs—Montrose, Oakleigh, Walter Place and Wakefield—equal the finest mansions of Natchez and Columbus. Devastated by sixty-two raids during the Civil War, a yellow fever epidemic in 1878 and relentless erosion of croplands, Holly Springs never again enjoyed the prosperity of the mid-nineteenth century, but it still retains the atmosphere of genteel elegance established then. Some of the unique examples of that era's architecture are gone, leaving only their stories as a mirror of the town's development and its early citizens.

Before Holly Springs and Marshall County were officially incorporated, Volney Peel moved to the territory from Huntsville, Alabama, to practice civil engineering. Instrumental in organizing the new county, he began building HICKORY PARK in

Hickory Park, roofline
and crumbling facade
visible above decades of
uncontrolled growth.
Photo courtesy of Chesley
Smith.

Hickory Park, detail
of Federal fanlight over
doorway. Photo courtesy
of Chesley Smith.

Hickory Park, interior
hallway with panelled
wainscoting and doors.
Photo courtesy of Chesley
Smith.

the Laws Hill community around 1833. The first house in the area to be constructed of brick, it incorporated many fine features of the old Tidewater mansions. Graceful semicircular fanlights graced the entranceways; masons laid handmade bricks in a fine Flemish bond over the sandstone foundation. The first floor comprised four twenty-foot-square rooms divided by a twenty-by-fifty-foot hallway. The two rooms on the right served as twin parlors, with the rear one including a stairway leading to the girls' rooms on the second floor. On the left, the front room was a large library with built-in windowseats for storage. In a closet was a second set of stairs, these leading to the boys' rooms above. Oddly, the entire upstairs level was divided by a wall, separating the girls' rooms totally from the boys'. Behind the library was a dining room; the kitchen was located in a separate building.

Volney Peel had five sons; the oldest was Confederate surgeon R. H. Peel. Dr. Peel sold the house in 1874 to a Mr. Wright, who in turn sold it back to the Peel family in 1897. It passed through another generation of the Peel family before being abandoned

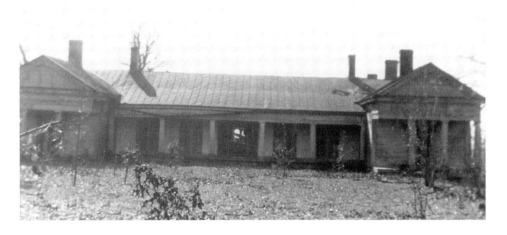

Galena, front elevation. The Cox house was arranged in a unique H-shaped plan. Photo courtesy of Chesley Smith.

in the early 1900s. Holly Springs natives recall making late-night forays to explore the lonely house, climbing through vines and weeds to admire the massive furniture gathering dust inside. A huge safe remained in the house, and more than one nocturnal explosion rocked the countryside as adventurous treasure hunters vied to open the vault. Exasperated by trespassers, neighbors of the old place finally had it demolished in the 1940s.

Soon after the Peels' classic home was built, wealthy South Carolina planter William Henry Cox joined the ranks of land speculators in the old Chickasaw territory. Rather than tackling the new land himself, he sent his five obstreperous sons off to sow their oats and plant their cotton in Mississippi. They collaborated to build a Greek Revival house called GALENA. Photos of this unusual structure are rare and faded, but a WPA observer in 1937 described it thus: "Low and broad, it is but one story high and rambles into a sturdy yet graceful 'H', its broad porch extending across the center hall and front rooms . . . the gray of the frame walls is so drab and blotched that even the remaining chips of paint are practically drained of color . . . the original furnishings are in disorder, as if thrust aside in haste a half century ago when the house was vacated."[1]

Galena is a Scottish mineral symbolic of peace, but the home of that name was rarely a peaceful place. The Cox brothers, by tradition, were notorious carousers and partiers, and legends of wild living at Galena have been passed down through the years. The scion of his generation, William Henry, Jr., supposedly broke his neck while riding his horse up the steps of the house; his brother Toby killed his wife and himself in a drunken spree. Another brother drove his team of horses off the levee at Memphis and drowned in the Mississippi River. Somehow, in spite of the family shenanigans, William Henry managed to run a model plantation, reknowned statewide for its productivity and size. He left Galena to his daughter, who sold it to an uncle, and then reinherited it from him at his death.

Abandoned like Hickory Park, Galena stood empty for a half century, gradually crumbling in on itself past the point of salvageability. No trace remains today of the

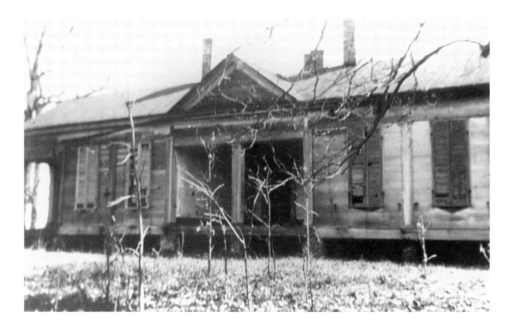

Galena, side elevation. The side porch opened off a sitting room. Photo courtesy of Chesley Smith.

Galena, floor plan. The two front bedrooms, having no interior doorways, were accessible only from the twin porticoes and the front porch. Illustration by Hugh H. Rather, architect.

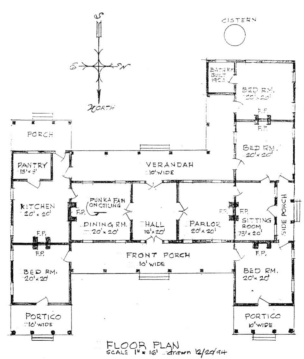

FLOOR PLAN
SCALE 1" = 16' drawn 12/20/94

GALENA PLANTATION HOME - Built 1845

Built in Marshall County, MS by Mathew James Coxe (1819-86).
Floor Plan drawn by Hugh H. Rather, Architect from a sketch by
Moultrie Lacey who had lived here during the 1920's & 30's with his
mother, 2 brothers, and grandmother. The Laceys were related to the
Coxe family, who also built "Airlewood" mansion in Holly Springs, MS. in 1858.
Tom & Moultrie Lacey later farmed this plantation's land for several years.
This home, now demolished, was located near Highway #4 West.
Mrs. L.A. (Chesley) Smith, Jr. took photos of this home while it was still standing,
which preserved its appearance for posterity.

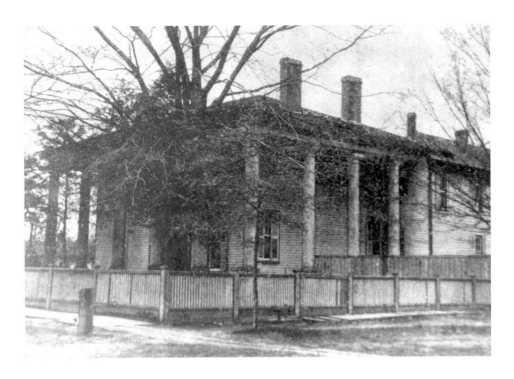

J. W. C. Watson House, later the main building of Mississippi Synodical College. Photo courtesy of Chesley Smith.

house where the high-spirited Cox brothers carved a plantation out of the Mississippi wilderness.

Holly Springs's greatest building boom came during the cotton-rich years of the 1850s, and one of the finest houses in town was that of Judge J. W. C. Watson. A Virginia native who moved to Mississippi in 1845, he was a staunch opponent of secession in the volatile years before the Civil War. Bowing to local sentiment, he served in the Confederate Congress and was a stabilizing influence in the Reconstruction era.

Around 1845, Judge Watson built his fine Greek Revival home on College Avenue, one block east of the courthouse. Colossal Doric order columns wrapped around three and a half elevations of the two-story WATSON HOUSE, supporting a finely detailed classical cornice. The Watsons raised eight children in the spacious rooms; two of their sons died in the Civil War. Daughter Elizabeth, who also lost her fiance in battle, was determined to send her younger brothers off to the University of Virginia rather than have them join the Confederate army. To raise the money in the depressed economy of wartime Mississippi, she started a girls' school, Maury Institute, in the house. The premier class included one of the state's first nationally known writers, Sherwood Bonner. The school was a success, and in 1890 it became North Mississippi Presbyterian College. As it outgrew the Watson mansion, new buildings were added, and in 1893 the name was changed to Mississippi Synodical College. After the institution merged with Belhaven in 1939, the spacious old house was felt to have outlived its usefulness, and it was torn down in 1945. Of the campus complex, only the building housing the Marshall County Historical Society Museum remains.

Another house destined to become a school was erected by Dr. David Pointer in

Holly Springs

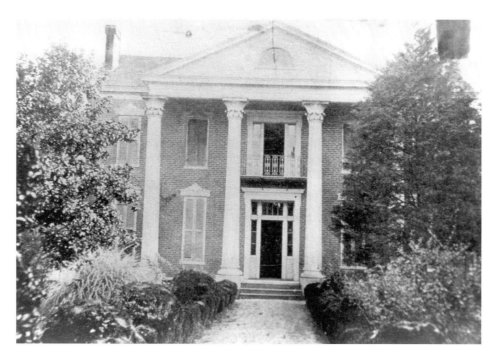

St. Thomas Hall, a prestigious military school of the late 1800s. Photo courtesy of Chesley Smith.

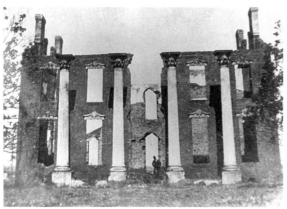

St. Thomas Hall, in ruins following 1898 fire. Photo courtesy of Chesley Smith.

Morro Castle, conjectural elevation. Work on the house was halted by the Civil War; the front portion was never finished. Illustration courtesy of Hugh H. Rather, architect.

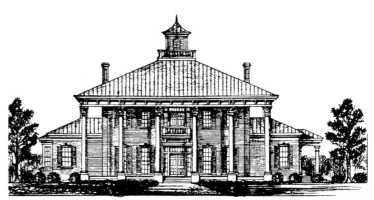

FRONT (NORTH) ELEVATION
SCALE: 1/16" = 1'-0"
THE HOUSE WOULD HAVE LOOKED SIMILAR TO THIS IF IT HAD BEEN COMPLETED. THE WAR BETWEEN THE STATES CAUSED THE WORK TO STOP UNCOMPLETED.

ONLY THE BRICK WALLS OF THE FRONT TWO STOREY PORTION WAS BUILT. THE TWO REAR ONE STOREY WINGS WERE FINISHED AND LIVED IN BY WILLIAM BLANTON LUMPKIN UNTIL HIS DEATH IN 1877.

THE HOUSE STOOD ON A HIGH ELEVATION, AND THUS A PERSON ON THE OBSERVATION CUPOLA WOULD HAVE BEEN ABLE TO GET A GENERAL VIEW OF MUCH OF THE SURROUNDING PLANTATION LAND.

the late 1850s. He had come to Mississippi from Virginia with his intriguingly named wife, Obedience, and their eight children. Financial success came from his practice of medicine as well as from vast cotton acreage, and shortly before the war he built a magnificent house on Salem Street. Strikingly symmetrical, its huge portico was supported by four Corinthian columns. Photos show marble detailing over the windows and a delicate wrought-iron balcony on the second floor.

Dr. Pointer was ruined financially by the Civil War, and the house passed out of family hands. In 1869, the mansion was sold to the Catholic Church for use as Bethlehem Academy, and it later became St. Thomas Hall, a military school. During Christmas week in 1898, the building burned. Photos taken around 1900 show only the columns remaining.

The house that might have claimed the honor of being north Mississippi's grandest home was never completed; its history was strangely similar to that of Natchez's Longwood. William Blanton Lumpkin, a member of a prominent Georgia political family, chose to relocate to Holly Springs in 1836. He constructed an enormous four-story mill and dammed up two ponds to provide it with water power. Profits from this business and his extensive landholdings added to his already considerable family fortune,

and by 1860 he was ready to begin work on Morro Castle. Intended to be the ultimate architectural display in the area, it was laid out to include at least twenty-two rooms, divided between a two-story central section and two one-story ells extending behind the main structure. Six Corinthian columns would have supported the hipped roof, topped by a cupola. Racing against time and gathering war clouds, Lumpkin's workers managed to lay the sandstone foundation and begin the massive front facade; the two ells were near completion when the

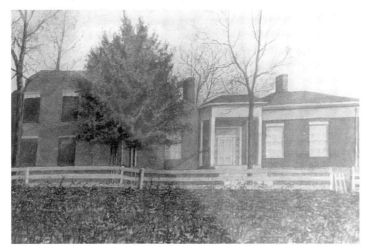

Morro Castle, as it appeared in the 1930s. Reproduced from a painting in the possession of May Alice Booker, artist unknown.

Civil War intervened. Tools and lumber were tossed aside, the marble mantels were left propped in the unfinished rooms, and years passed with no progress on the mansion.

War's end found William Lumpkin in as sad a financial condition as many of his contemporaries, his mill burned and fortune gone. Unable to finish the great house, he roofed over the ells and lived there until his death in 1877. Over the next half century, the untended formal gardens and groves of juniper and spruce trees crept toward the deserted house, which was eventually covered with vines and creepers. For decades the empty shell stood as a bizarre reminder of a dream that was never realized. In the 1930s, the remaining sandstone blocks and bricks were cleared away and the entire site disappeared beneath the waters of a lake dug for Wall Doxey State Park.

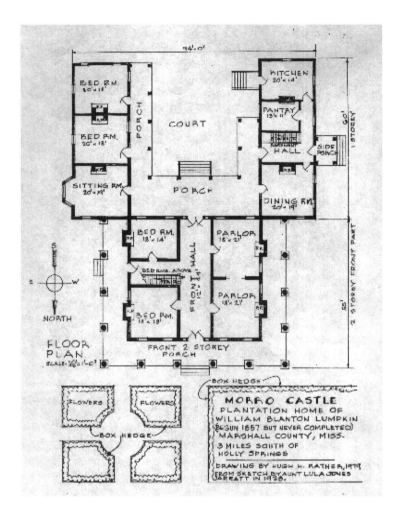

Morro Castle, floor plan. Illustration courtesy of Hugh H. Rather, architect.

Peter Scales was more successful than William Lumpkin in realizing his architectural aspirations; his OAK-LAND was a three-story mansion near Hudsonville, completed around 1850. A family member described the house in a family history:

"Oakland" was set on a rise and surrounded by a large oak grove. The house consisted of three stories. The first two were of brick and the upper, or top, was of weather boarding. There was a double stair case on the outside that came up on either side of double doors on the second floor— very like some of the homes on the Coast and in New Orleans; and visitors entering always went up the stairs to the second floor. The double front doors opened into a wide hall, on one side of which were the drawing rooms. On the other side of the hall, opposite the drawing rooms, were the bedrooms. . . . There were two bedrooms and store rooms on the third floor. In front of the downstairs entrance, across the entire front of the house, it was paved with brick, where they could sit—like a terrace. The downstairs entrance had double doors, corresponding to those on the second floor; and these doors also opened into a wide hall. The dining room and kitchen and Grandma Scales' bedroom were on this floor. The house was torn down . . . by the Hudsons who bought it, as by that time it was in bad repair.[2]

Oakland was the boyhood home of Lieutenant Dabney M. Scales, an Annapolis student who left the naval academy at the outbreak of the Civil War. Joining the Confederate navy, he served on the C.S.S. *Shenandoah*, a three-masted schooner that spent its war career in the Pacific and Arctic waters capturing whaling ships. Lieutenant Scales was on board when the last shots of the Civil War were fired, oddly enough, in the Bering Strait, four months after Lee's surrender at Appomattox. Following the war, he pursued a legal career in Memphis, never again occupying the short-lived Oakland.

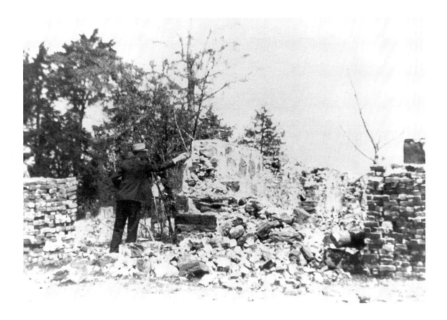

Morro Castle, ruins being dismantled. Note large blocks of sandstone used in foundation. Photo courtesy of Chesley Smith.

Oakland, conjectural elevation. Illustration courtesy of Hugh H. Rather, architect.

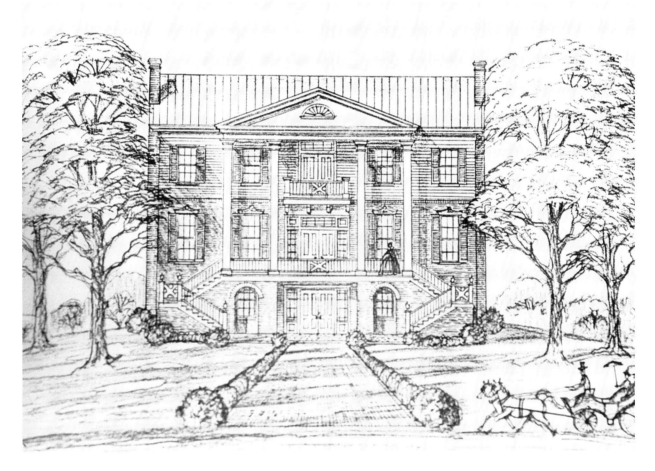

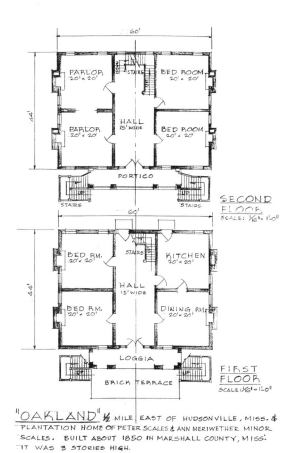

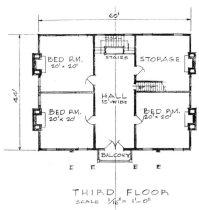

SECOND
FLOOR
SCALE: 1/16" = 1'-0"

FIRST
FLOOR
SCALE: 1/16" = 1'-0"

THIRD FLOOR
SCALE 1/16" = 1'-0"

"OAKLAND" 1/2 MILE EAST OF HUDSONVILLE, MISS. & PLANTATION HOME OF PETER SCALES & ANN MERIWETHER MINOR SCALES. BUILT ABOUT 1850 IN MARSHALL COUNTY, MISS. IT WAS 3 STORIES HIGH.

RESEARCHED & DRAWN BY HUGH H. RATHER, ARCHITECT— 1981
PAGE 2 of 3 PAGES

"OAKLAND" 1/2 MILE EAST OF HUDSONVILLE, MISS. IN MARSHALL COUNTY & PLANTATION HOME OF PETER SCALES & ANN MERIWETHER MINOR SCALES. IT WAS LOCATED ABOUT 1/2 MILE EAST OF THE RAILROAD TRACKS AT HUDSONVILLE ON TOP OF A HILL IN A GROVE OF LARGE OAK TREES.

THE HOUSE WAS DEMOLISHED MANY YEARS AGO. A DESCRIPTION OF THIS HOME BY MRS. LILLIAN GRAY WALL WAS INCLUDED IN THE FAMILY BOOK:— "MINOR, SCALES, COTTRELL, AND GRAY FAMILIES OF VIRGINIA, NORTH CAROLINA, AND MISSISSIPPI" COMPILED AND EDITED BY MARTHA NEVILLE LUMPKIN.

RESEARCHED & DRAWN BY HUGH H. RATHER
ARCHITECT—1981

Oakland, floor plan.
Illustration courtesy of
Hugh H. Rather, archi-
tect.

Ripley

Thirty miles due east of Holly Springs is Ripley, another town growing out of the 1832 Chickasaw cession. Classically southern, its commercial buildings clustered around an imposing courthouse, Ripley was incorporated in May 1837. Within its first decade, two families would migrate there whose interactions would give the community an air of lawless violence more reminiscent of the Wild West than of the Old South; ironically, these very families found time between shootouts to build Tippah County's two most memorable homes.

Thomas Carmichael Hindman, Sr., a Tennessee native, served as a lieutenant under General Andrew Jackson at the Battle of New Orleans in 1815. A planter of considerable fortune by the 1830s, he floated his family down the Tennessee River to Alabama and acquired extensive landholdings there over several years. Opportunity again beckoned when his old commander, now President Jackson, began looking for supervisors to oversee the relocation of the Cherokee Indians from Alabama to Oklahoma. Hindman offered his services and those of his brother-in-law; both men finished their tour of duty considerably richer. In 1841, Hindman traded his Alabama land for the richer soil of north Mississippi and prepared to move his family, servants and possessions to Ripley.

Thomas Hindman had no intention of "roughing it" on his new plantation; eighty years after the move, his youngest daughter, Mildred Hindman Doxey, recalled the relocation: "He [Hindman] had a ten room house made of logs hewed down smoothly. He had lumber for floors, doors, window sashes—all heavy timber—all sawed at the place. Father stayed there until the house was put up. They covered the floors down, then he returned to Alabama to move us." Mildred vividly remembered her father's indignation at what, after an arduous wagon journey, he found on his return: "The house was not finished. Neither doors nor windows were in as they were made in the house. Soon they got lumber and had several carpenters and had everything so comfortable real soon."[1]

The HINDMAN HOUSE was a frontier version of the Greek Revival mansions being built in Holly Springs and Columbus. Clapboards covered the logs, and old photos show no elaborate lintels or pilasters to ornament the facade. Five bays were fronted by a classical portico, a symmetrical arrangement that was not extended to the

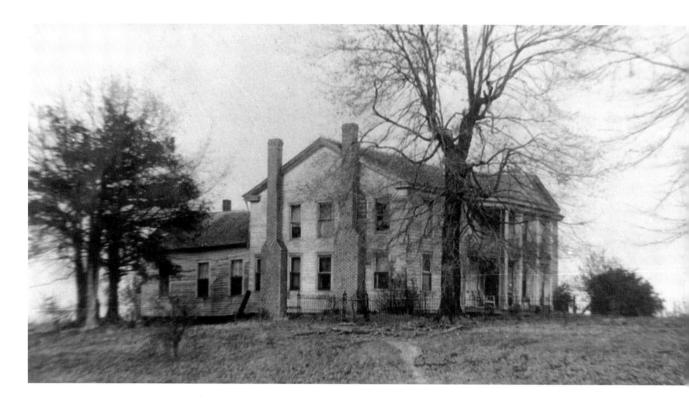

Hindman House. Robert Hindman was buried near the house after being killed by William Falkner in 1849. Photo courtesy of Ripley Public Library.

sides of the structure. Twin chimneys on each gable end were placed between irregularly spaced windows; this asymmetry may have been a result of alterations or additions made in later years. A one-story ell extended from the left rear of the house. Viewed from the road, this huge square-columned house was a rare sight in sparsely settled Tippah County.

The Hindman family included six children. Two of the sons, Thomas C. Hindman, Jr., and Robert Holt Hindman, were contemporaries of another recent arrival to Ripley, William Clark Falkner. According to family legend, the teenage Falkner walked from Missouri to Mississippi looking for his uncle, John Wesley Thompson. Thompson was, unfortunately, in jail awaiting trial for murder when his nephew limped into town. After his acquittal on those charges, Thompson allowed William to study law with him, and the young Falkner was on his way to a remarkable life as a public figure in Ripley.

Along with the Hindman brothers, Falkner volunteered for Mexican War service; he was home within months, discharged after having had three fingers on his left hand shot away. Thomas and Robert Hindman were also back home, and trouble was brewing among the three young men, partly because Falkner's new bride, heiress Holland Pearce, was supposedly a favorite of Robert's. His jealousy was exacerbated when he was "blackballed" from the local chapter of the Sons of Temperance. Confronting Falkner with his suspicions of the blackballer's identity, Hindman drew a gun on him. Falkner wrestled the weapon away and pulled a knife, fatally stabbing his assailant. Robert Hindman's body was carried back to the family plantation, where he was

buried under a headstone reading "Killed at Ripley, Miss. By Wm. C. Falkner, May 8, 1849."

Bad feelings persisted between the Falkners and Hindmans; a duel between Thomas, Jr., and Falkner was narrowly averted by bystanders, and Thomas, Sr., attempted to shoot Falkner in a local hotel. Despite his running feud with such a locally prominent family, Falkner's ambitions were propelling him up the social and economic ladder of Tippah County. He served briefly in the Confederate army, but apparently spent most of the war running the blockade between Mississippi and Union-occupied Memphis. His home was lost to a fire started by Federal troops in 1864, and he used some of his blockade profits to purchase an entire city block the following year. The original house that he built there was a simple one-story structure with two outbuildings, but it was destined to be transformed into one of Mississippi's most unusual homes as Falkner's fortunes improved.

During and after Reconstruction, Falkner displayed a talent for making money, joining local businessman R. T. Thurmond in building a railroad from Ripley to Middleton, Tennessee. Foreshadowing the career of his famous great-grandson, he published a romantic novel, *The White Rose of Memphis*, and left to tour Europe with his daughter, Effie. Impressed with the classical architecture of France and Italy, Falkner returned to Ripley determined to transform his plain home into an Italian villa. The result was a three-story oddity, which would hold a unique place in Mississippi architecture for almost sixty years.

The reconstructed FALKNER HOUSE was square with a central tower, sporting gables on each side of the second floor. Gothic-arched windows opened onto fanciful iron balconies, and portholes, bracketed eaves and a widow's walk gave this home a Victorian flair rarely seen in post-Reconstruction Mississippi. The floor plan was described by a visitor wandering through the soon-to-be-demolished structure in 1937:

> On entering the south door of this imposing old home one feels the grandeur . . . the polished floors, the high ceilings, the long hall with the massive stairway making its gradual ascent to the second story, and its interesting ironwork rail is marked with splendor. To our left we enter the spacious living room with its high windows, reaching almost from floor to ceiling, and the huge old fireplace with high mantel. . . . Entering through large rolling doors, we now look upon the celebrated dining room. The enormity of the room is felt, however retaining the dignity and beauty. . . . The enormous old fireplace in the north end lends a friendly touch. . . . We will now visit the suite of bedrooms on the east side of the hall—both are the same size (larger than most of our living rooms of today), and each accommodating giant fireplaces and built in chimneys. The mantels are also very pretty. The three windows and outside doors in each room make them light and airy. The second floor has one high room with four gables, [and] each gable (with the exception of the north one that accommodates the stairs) will hold a small bed or probably a large one. The doors leading from the gables into the enclosed balconies make it possible to pace around the

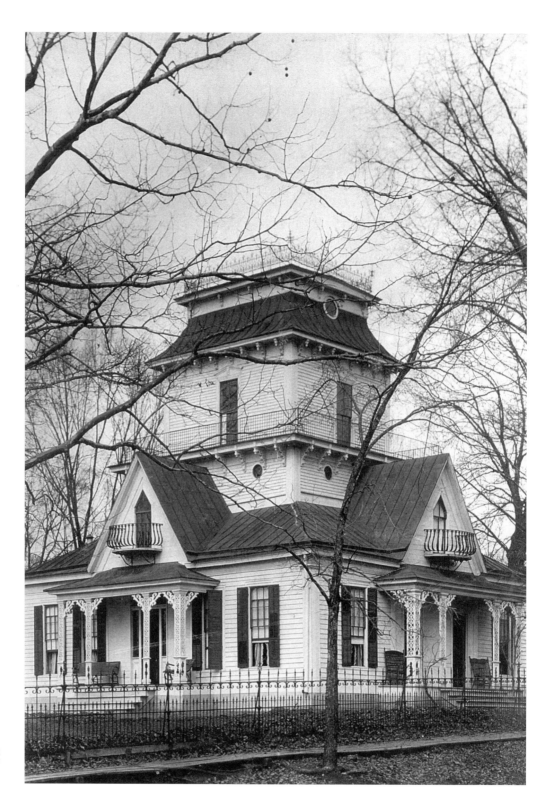

Falkner House. William Falkner renovated his house to resemble the Italian villas he admired in Europe. Photo courtesy of Ripley Public Library.

inner room without entering it. Each balcony has two portholes. The third story accommodates one large room with a window in each side, giving the occupant free access to a view of Ripley from every angle. Last . . . the kitchen [is] set off by itself and approached by a covered passage. With its four windows and three doors it was at that time a kitchen to be envied by any house wife. The house-office and storage room are at an angle and west of the kitchen, [and are] also approached by a covered passage.[2]

Surrounding the house was an elaborate iron fence, reportedly salvaged from Court Square in Memphis. William Falkner lived largely alone in the great house, his family having moved to Memphis, but he only enjoyed his "red-roofed house of the balconies" for a few brief years. He was gunned down on the courthouse square in 1889, not by his old enemies, the Hindmans (who had long since moved to Arkansas), but by his former partner, R. T. Thurmond. Falkner's manner and lifestyle, however, continued in a way to be on view, as he was the likely model for William Faulkner's Colonel Sartoris.

The Falkner House and the Hindman House were both gone by 1940. Falkner's house was torn down to make way for a new post office in 1938; some of its architectural elements were incorporated into the Ripley Medical Clinic. The Hindman House, which had passed into the Booker family, was lost that same year to fire. Internationally renowned concert pianist Gibson Booker, who had grown up in the old mansion, managed to pull a Steinway grand piano from the burning structure, and that piano sits today in the Ripley Public Library. Only the Hindman cemetery remains on the old homesite, its stone indictment of William Falkner still standing over Robert Hindman's grave.

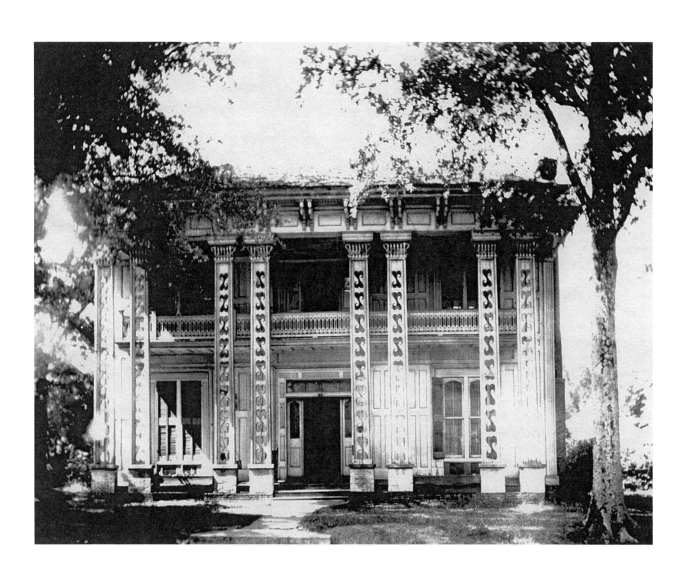

Aberdeen

Situated on the west bank of the Tombigbee River, Aberdeen grew from a Scotsman's vision into one of antebellum Mississippi's most architecturally diverse communities. Robert Gordon, an immigrant from Great Britain, was drawn to the Indian lands as a jewelry trader. His contacts among the local tribes made his influence invaluable when the United States government was ready to persuade the Chickasaws to move west. Gordon was rewarded for his diplomatic efforts with extensive land grants in the Tombigbee Valley. He wasted no time in building a trading post on the river; the settlement that grew up around it was originally called Dundee, but the American inability to pronounce it with a proper Scottish inflection prompted Gordon to change the name to Aberdeen. Gordon himself did not settle permanently in his new town, but moved on to land near Pontotoc, where he built the landmark Greek Revival mansion Lochinvar.

In May 1837, Aberdeen was incorporated by the state legislature, and in 1849 it was chosen as the county seat of Monroe County. The transformation from pioneer outpost to plantation center was rapid, with five thousand citizens calling it home by 1850. As with Holly Springs, many of those who came to take advantage of the rich prairie soil along the Tombigbee were sons of prosperous Atlantic Coast planters, and culture followed in their wake. Newspapers, lyceums and literary magazines took the hard edge off life on America's southwest edge, and easy access to Mobile down the Tombigbee added even more prosperity to the town. Carpenters and brickmasons flocked in to build the mansions and town homes of those reaping wealth from their cotton fields and steamboats.

Several of Aberdeen's most remarkable homes are extant, including the Magnolias and Sunset Hill, but one which has disappeared was notable for its unusual exterior. The SPRATT-HERNDON HOUSE was built in 1844 by Henry Spratt, a trained physician who never actively practiced his craft. He moved to Monroe County from Kentucky in 1831 and served as mayor of Aberdeen in 1845. Shipping interests furnished his wealth, and after a decade in Mississippi he was ready to begin construction of his new home. The Spratt-Herndon House had two distinctly different sections, a one-story brick wing and a two-story frame facade. It is unknown which section Dr. Spratt built and which part was added at a later date. Regardless, the final structure was one of the most elaborately detailed houses in Mississippi.

Spratt-Herndon House, featuring some of the most elaborate detail work seen in antebellum Mississippi. Photo courtesy of Evans Memorial Library, Aberdeen.

McNairy House. This structure eventually disappeared behind the facade of a hotel. Photo courtesy of Evans Memorial Library, Aberdeen.

Photos of the Spratt-Herndon House show an exceptional wealth of architectural elements: eight pierced columns, grouped in pairs across the front, rose from brick piers to end in unusual carved capitals. A full entablature was placed over large paired brackets, and the porch ceiling was deeply coffered. Coordinated with the ceiling were recessed panels across the facade, separating Gothic-arched windows and doorway. A finely carved bannister ran the length of the second-floor balcony. On each side of the main house were full-height chimneys with pointed arches worked into the masonry. Surprisingly, given such an elaborate facade, the house was only one room deep on each side of the center hallway. A spiral stair rose from the right side of the hall, leading to two additional rooms on the second floor.

Extending from the right rear of the house was the one-story brick wing housing five additional rooms. Whichever portion of the house existed in 1848 was sold by Dr. Spratt to Mrs. Edward Herndon, and she may have added the remaining rooms or commissioned the fanciful portico. The house passed through several families before falling to the wrecking ball in 1938.

The McNairy House was a product of the same era, but its stark, heavy appearance offered a startling contrast to the exuberant detailing found in the Spratt-Herndon House. Greek Revival in design, with square columns and enormous dentil carving under the cornice, it was built as a private residence around 1847. Following the Civil War, it was turned into a boardinghouse; in 1905, a large addition was completed to accommodate more lodgers. Renamed the Clopton Hotel, the original house gradually vanished into the interior of a progressively enlarging hostelry. By the time it came to be known as the Parkway Hotel, photos show no evidence of the massive columns and Greek Revival facade that marked the McNairy House. The hotel was torn down in the 1950s, its dismantlers probably unaware that they were peeling away layers of wood and brick hiding an antebellum mansion.

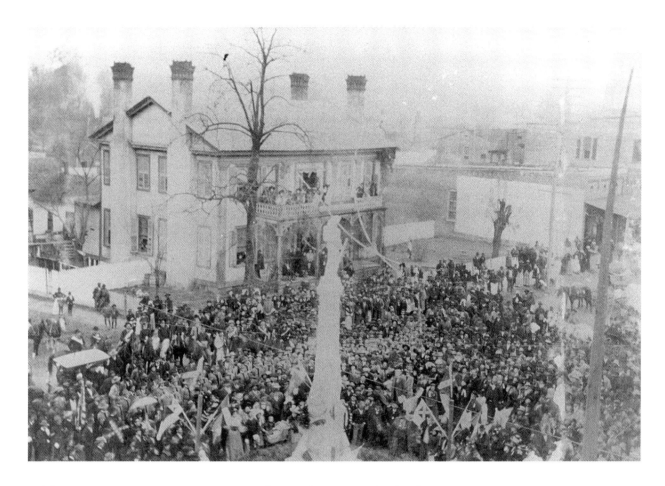

The Griffin-Dortch House, long a fixture on Aberdeen's main street, was described in its last years as "enshrouded in lush green growth . . . many people [feeling] that the only thing supporting it were the entangling wisteria vines."[1] This house was built by Reverend Addison Lea in 1851; he had settled in Aberdeen to open a school for girls. For his personal residence he chose a two-story frame house with Gothic detailing. An arched porch ran the length of the first floor, and four brick chimneys were decorated with crenelated tops. Inside, the central hallway featured a mahogany staircase running up the right wall, turning to a landing on the back wall and turning again to ascend to the second-floor bedrooms. Double parlors were joined by sliding doors on the left side of the hall; the library and dining room were to the right of the stair.

Reverend Lea's school was located behind this fine house; both school and home were sold to General Lewis Griffin in 1857. Griffin was a man with a varied history, having served as an Indian fighter, railroad president, banker and founder of Griffin, Georgia. His granddaughter, Bessie Griffin Dortch, was a maiden lady whose personality and hospitality were legendary in early twentieth-century Aberdeen. Her cousin, Robert Ivy, Sr., of Columbus, fondly remembered visiting her in the 1920s:

Griffin-Dortch House, where "Cousin Bessie" ruled over Aberdeen's Main Street. Photo courtesy of Evans Memorial Library, Aberdeen.

She lived across the street from City Hall, right in downtown Aberdeen, in a large, two-story house literally held up by the wisteria vines that shaded and sheltered the front porch. Her porch was an Aberdeen institution, the perfect place for visiting. Each morning she plumped the cushions in the chairs and got ready for the company that would certainly fill them that afternoon. If there happened to be a parade that day, callers would come early to get a seat. Downstairs Cousin Bessie had formal double parlors filled with handsome rosewood and mahogany antique furniture. There were several bedrooms downstairs, a wide hall, a large dining room; and in a separate structure, joined to the rest of the house by a latticed hall, was the large kitchen presided over by Fussy, the cook. . . . As we sat on the porch in the late morning, passersby called to say good morning and to exchange family information with Cousin Bessie. If someone black or white happened to go by without speaking, Cousin Bessie would call out, "Don't I know you?" It was inconceivable that she would not.[2]

The home that young Robert Ivy visited had been altered from its antebellum appearance; a turn-of-the-century photo shows crowds on the flat porch roof watching the dedication of Aberdeen's Confederate monument. By the 1920s this porch had been shortened to a smaller, gabled affair. As Miss Dortch aged, the creeping vines and bushes in the front yard steadily worked their way up the sides of the house, and by the time of her death in 1948, the old home had practically disappeared underneath the greenery. With no one willing to take on such a forest, and the site having more value as commercial property, the hospitable Griffin-Dortch House was dismantled in 1949.

Two other Aberdeen houses were notable, not so much for their style or floor plan as for the remarkable craftsmanship shown in their porch detailing. The GATTMAN HOUSE, a simple two-room frame dwelling, was most likely constructed in the early 1860s. It was enlarged by banker Jacob Gattman in 1868, and he later sold it to his nephew, Meyer Gattman. Meyer hired Swedish craftsman Carl Otto Anderson to add scrollwork across the front porch, in keeping with the prevailing Victorian designs. Anderson's woodworking was masterful: delicate curlicues, stars and circles spanned the spaces between slender square columns.

Meyer Gattman enjoyed his Victorian cottage for twenty years, maintaining the image of a respectable banker. Unknown to his investors, however, he was gambling with cotton futures on the side; pressed for funds, he embezzled large amounts from the family bank and absconded to Canada in 1888, setting off a local financial panic. Many years later, one of Gattman's descendants sent a generous contribution to the Aberdeen Public Library. No indication was given as to whether the family was aware of the illicit origins of their wealth.

Carl Otto Anderson was probably responsible for the scrollwork on the LAMBETH-MILLIGAN HOUSE, a two-story farmhouse located across the Tombigbee River from Aberdeen. The details in the woodwork were identical to those on the Gattman House, and they were the only decorative element on the simple, front-

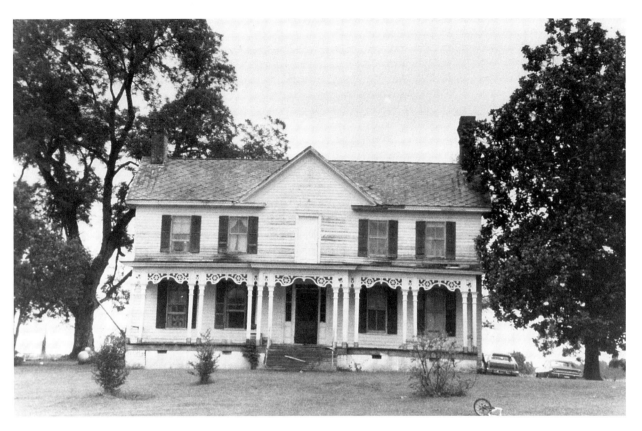

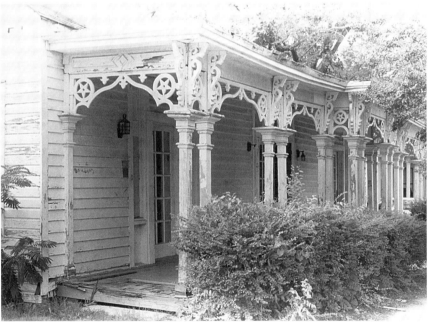

Lambeth-Milligan House, with scrollwork identical to that found on the Gattman House. Photo courtesy of Evans Memorial Library, Aberdeen.

Gattman House. The elaborate scrollwork across front portico was done by Swedish craftsman Carl Anderson. Photo courtesy of Evans Memorial Library, Aberdeen.

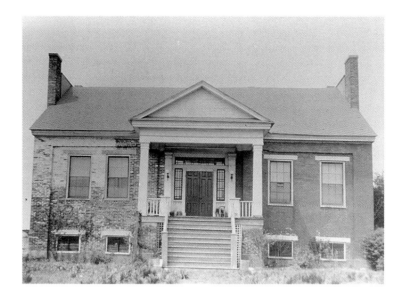

gabled structure. At some point, this house had an upstairs gallery; after its removal, a door was left incongruously opening onto the porch roof. On the interior, twin circular stairs led to upstairs suites separated by a wall, much like the arrangement in Holly Springs's Hickory Park.

Regrettably, neither of these homes graced with Carl Anderson's careful detailing survives; the Lambeth-Milligan House burned in the 1980s, and the Gattman House was demolished in 1984 after repeated attempts to save it failed.

An early "suburb" of Aberdeen was Gladneyville, developed by Reverend Richard Gladney in the 1850s. Several fine homes were built here for local planters, the best documented being the BRADFORD HOUSE. General Benjamin Bradford owned a twenty-two-hundred-acre plantation in Choctaw County, and, like so many of his financially well-to-do contemporaries, he also invested in banking and railroad interests. In November 1854, Bradford purchased land from Reverend Gladney and began construction of his gracious brick residence. Rigidly symmetrical and simple, it was a one-and-a-half-story Greek Revival design with a full raised basement. A steep staircase led to the sidelighted front door. The hallway was an unusual lobby-like arrangement, opening to the second floor, with stairway landings overlooking the main entrance. In the basement, four rooms had brick walls and floors, and each room had its own fireplace. Twin chimneys on each gable end of the house were separated by three windows and joined together with a parapet at the roofline.

A one-story addition on the right side of the house is seen in early photos; it was likely destroyed or badly damaged in the 1920 tornado that devastated Gladneyville. By that date, the house had long since passed out of the Bradford family, the general having lost most of his fortune in a failed railroad venture. WPA pictures from 1937 show the sturdy house hiding its years well despite abandonment. A victim of encroaching commercial development, it was torn down in 1960.

CHAPTER TEN

Columbus

The northern prairie's answer to Natchez was Columbus, a town ideally situated on the Tombigbee River where Andrew Jackson's Military Road ferried across on its way to Louisiana. Surrounded by rich cotton land, it shared in the explosive population shift into Mississippi during the decades before 1860. Just as Columbus reached its economic peak, nineteenth-century American architecture was at its most expressive. Columbus has been fortunate in retaining a remarkable number of antebellum mansions; its losses have been heaviest among the Victorian mansions that once lined the streets. Two losses from the antebellum period were particularly regrettable, however, since they were prime examples of the architectural style that came to be known as Columbus Eclectic.

In the 1850s, local builders began to merge elements of the three prevailing national architectural styles into one, an eclectic mix that would be seen only in the Lowndes County area. The massive main block of Greek Revival was retained but enhanced with the arches and tracery of Gothic style and the towers and heavy cornice bracketing of the Italianate. Flynnwood was built at the height of this period, and it probably best typified the creativeness of these Columbus builders of the 1850s.

Colonel Bill Humphries promised his new bride the finest house in Columbus, and had his architect incorporate a variety of details into their home to achieve that goal. FLYNNWOOD was a two-story house with a full-height arched portico, incorporating Gothic, Tudor and baskethandle archwork over octagonal columns. All the arches were outlined with delicate tracework, mirroring three elaborately balustraded balconies. The cornices featured heavy brackets. A side porch also exhibited a variety of arches and a balustrade, and fan-shaped Venetian glass outlined the front door. Inside, the eight rooms were divided by two large halls; solid pine floors and a mahogany staircase were reflected in the crystals of twelve chandeliers.

Flynnwood burned in 1966, while serving as a combined residence and music store. The salvageable architectural elements from it were dismantled and stored in a warehouse in Memphis.

Another example of Columbus Eclectic was the CAYCE HOUSE, built in the 1850s but carrying the name of a turn-of-the-century judge who lived there for many years. While not as finely detailed as Flynnwood, it too featured flattened Tudor

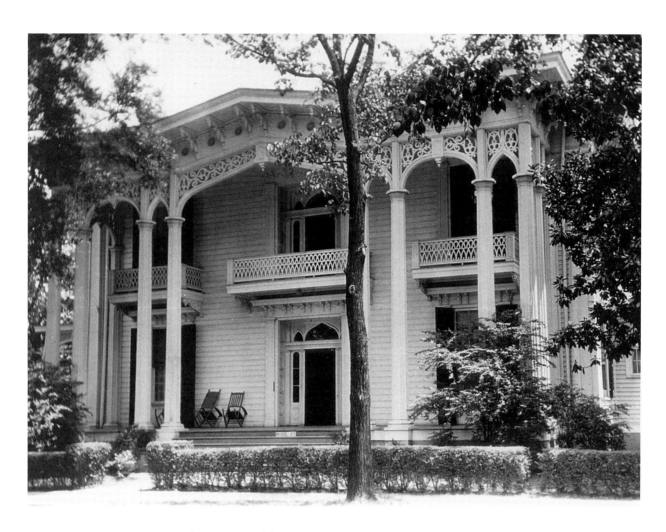

Flynnwood, a classic example of the Columbus Eclectic Style. The front elevation demonstrates a central Tudor arch, pointed Gothic arches and unusual baskethandle arches in between. Photo courtesy of MDAH.

arches supported by paired octagonal columns, all beneath a bracketed cornice. Balconies fronted the upstairs windows and door. Cayce House burned in 1912, leaving Errolton, Shadowlawn and the Fort House as the surviving examples of Columbus Eclectic design.

Gulf Coast

The Mississippi Gulf Coast traces its oldest settlements back to the arrival of French explorers in 1699, and many of the antebellum homes there reflect a strong Creole and West Indian influence in their design. Often, the main level of the houses is raised above an open basement, allowing wind-driven water to flow harmlessly underneath the living quarters. Broad, shaded galleries and floor-to-ceiling windows take advantage of cool gulf breezes. These elements were adapted over the first century and a half of the coast's history, and the results are seen in the gracious homes lining the beach roads from Waveland to Pascagoula.

On Mississippi's westernmost shoreline, WAVELAND and Pass Christian developed as resort communities for the rich merchants and planters of New Orleans and south Mississippi; some of the finest homes in pre–Civil War Mississippi were built there. One of the first New Orleans "businessmen" to locate in Waveland was a shadowy figure who has come down through history known only as Donahue. Supposedly a front man for the notorious pirate Jean Lafitte, Mr. Donahue constructed what came to be known as the PIRATE HOUSE. Perhaps dating from as early as 1802, it was a Louisiana raised cottage with a full-length front gallery and iron-railed steps. Wrought-iron balustrades joined the square white columns along the gallery; tall windows opened to face the water. Heavy shutters were attached with ornamental hinges, and symmetrically placed dormers complemented the hipped roof. The interior walls were covered with thick white plaster; wooden pegs and square nails attested to the early origins of the Pirate House.

Any house old enough to have witnessed the heyday of Caribbean pirates was bound to attract its own legends, and the Pirate House fit that bill perfectly. Mysterious doors and windowless basement rooms may or may not have been designed for stolen treasure; the secret tunnels that were said to lead from the cellar to the beach may have never existed at all. After Jean Lafitte's death in 1826, the enigmatic Donahue dropped from sight, and the house passed into more respectable hands. Generations of several different families came and went, and the house's sturdy construction saw it through some of the Gulf of Mexico's worst storms. When the Mississippi coast took a direct hit from the unparalleled force of Hurricane Camille in 1969, the aging pirate hideout was damaged so severely that it had to be demolished, taking with it the legends of buccaneers and buried treasure.

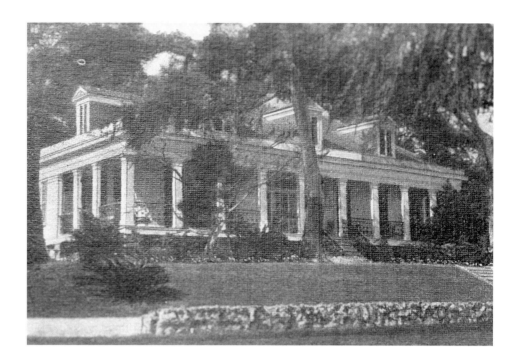

Pirate House, supposedly the hideaway of legendary pirate Jean Lafitte. Photo courtesy of Hancock County Historical Society.

Across the marshes from the Pirate House, another grand home was built around 1800. LAURELWOOD was not as elegant in its facade as the Pirate House, but its reputation and most famous inhabitant were polar opposites of its neighbor's. The builder was John Saucier, who had received a land grant from the Spanish government in the last years of the eighteenth century. His home was a West Indian-style structure with an elevated foundation, the main floors raised high above the ground on brick piers. The central core of the house was surrounded by wide porches, their slender columns supporting the hipped metal roof. Simple wooden balustrades connected the columns, and one set of unadorned steps led from ground level to the main floor. The dormers and chimneys were also simple, and a square observatory rose high above the marshes, affording views along the coastline. Laurelwood's interior was described as unusually spacious, with rooms opening off a central hall. In contrast to the plain exterior, the walls were covered with hunting scenes done by a New Orleans painter referred to as Coulon.

In the 1840s, Laurelwood became the writing retreat of Mississippi's first historian, John F. H. Claiborne. Claiborne was born into one of the state's most distinguished pioneer families; his uncle had served as territorial governor and his father had led Mississippi troops in the War of 1812. He served terms both in the state legislature and in Congress, edited a Natchez newspaper and lived in Cuba briefly before coming to the coast to fulfill his dream of writing a history of Mississippi. For twenty-five years, the secluded house on the marsh was his sanctuary. He completed biographies of Sam Dale and John Quitman, but the first manuscript of his history of the Southwest was lost in a steamer explosion. Volume one of *Mississippi as a Province, Territory and State* was published after Claiborne had moved to his wife's plantation near Natchez. When

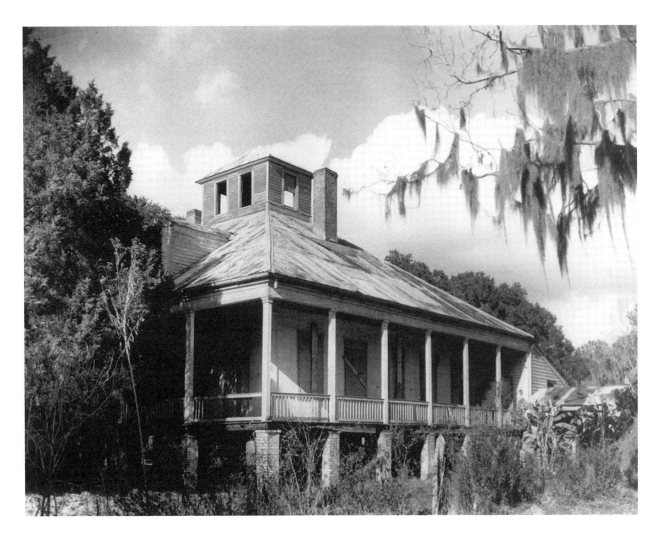

that house burned in 1884, all his work on volume two was lost, and Claiborne never recovered from the shock of that tragedy. He died in Natchez just a few weeks later.

The Claiborne House, as Laurelwood had come to be known, stood for almost one hundred years after Claiborne's death. The groves of pine and moss-draped live oaks grew above the roofline, shrouding the house in darkness. The rotting slave quarters and abandoned Claiborne cemetery behind the house heightened the foreboding atmosphere around it, and when a paper company bought the property, the house was sealed up. Efforts to have the state take responsibility for it were fruitless; deemed an unacceptable safety hazard in 1969, it was doomed to demolition soon afterwards.

East of Waveland, PASS CHRISTIAN was incorporated in 1838, and was soon renowned as the center of gracious living on the Gulf Coast. The South's first yacht club was organized there in 1849, and wealthy New Orleans citizens found it an ideal location for their second homes. Many of those antebellum retreats still grace the streets along the beachfront, but several have been lost to fire and to nature's fury over the years.

Laurelwood, J. F. H. Claiborne House. The first comprehensive history of Mississippi was written in this marshland house. Photo courtesy of MDAH.

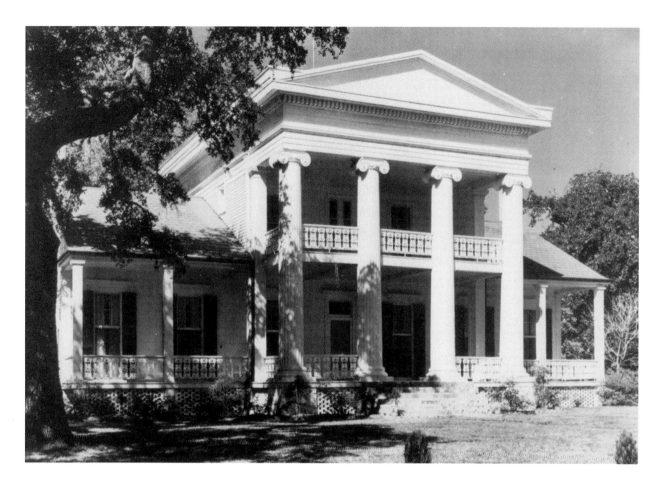

Ossian Hall, a rare Greek
Revival example of Gulf
Coast architecture. Photo
courtesy of Pass Christian
Historical Society.

 In 1848, Seth Guion began construction of his Greek Revival mansion in a section
of Pass Christian known as Beach Hurst. OSSIAN HALL was designed in the fash-
ion that prevailed in Natchez and Columbus. Shunning the stylistic adaptations suit-
ed to the coastline, Guion apparently felt that if he built his house solidly enough, its
sheer mass and strength would obviate the need for a raised basement. Four enormous
Ionic columns held the full entablature through a century of wind and waves. Upper
and lower galleries were framed by iron railings, and the central section of the house
was flanked by one-story wings.

 Ossian Hall passed through several families, with its beauty and romantic setting
among live oaks prompting Hollywood to use it as the centerpiece of at least one
long-forgotten movie. By 1950, though, it had been neglected for a number of years
and was beginning to sag noticeably. When New Orleans socialite Melanie DeBen
agreed to look at it while hunting beachfront property, she was repelled by the dilapi-
dated condition of the old house. Her daughter convinced her that this house still had
great potential, and that potential was once again realized when the DeBens renovat-
ed Ossian Hall. Mrs. DeBen opened a southern tearoom in the huge formal rooms,
and it became one of the coast's premier tourist attractions during the 1950s.

 Ossian Hall's reprieve was shortlived; early on a Sunday morning in 1954, a pho-

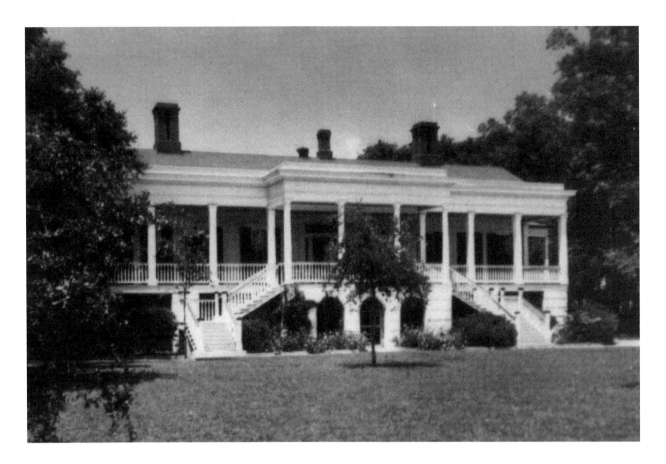

tographer noticed smoke curling out of the upstairs doorway as he stopped to take a picture. Fire trucks from towns all along the coast raced to try to save the landmark, but it was a futile effort; the next day's newspapers showed crowds of onlookers gathered in front of the blackened columns, staring at the roofless ruin. A state historical marker now marks the site of Ossian Hall.

Not far from Beach Hurst, a gentleman named John Backe commissioned a fine home in the years before the Civil War. Originally known as BEAULIAU, this house was the culmination of the raised planter style seen all along the beachfront. Elegant curved stone arches carried the front gallery over the open basement, and turned, divided stairs led up to the central landing. Arched windows were spaced along the front facade of the main floor, providing breeze and a wide view of the gulf.

Beauliau's moment of lasting fame came in 1913, when President Woodrow Wilson was given doctor's orders to rest following a prolonged bout of influenza. A former New Jersey neighbor offered him the use of her Pass Christian summer house, Beauliau, rented at the time to the Herndon family. Wilson accepted and headed south with his aides and press retinue. He spent several relaxing weeks on the coast, enjoying the beach and working on his golf game. Honorary membership in the local fire department was bestowed on the chief executive after his staff came to the rescue during a house fire.

Beauliau, Dixie White House, where President Woodrow Wilson relaxed and recuperated in 1913. Photo courtesy of Pass Christian Historical Society.

The president recovered fully and returned to the less aesthetic atmosphere of Washington, but he always remembered Beauliau as "a beautiful, peaceful place." The nickname "Dixie White House" remained with the home as it passed through several stages of diminishing occupation before finally being converted into a nursing home. Hurricane Camille smashed directly through Pass Christian and the Dixie White House in 1969, and it was razed the following year. Only a road marker remains to commemorate the house that once played host to the most powerful figure in America.

CHAPTER TWELVE

Delta

Each new section of Mississippi opened by Indian treaties brought settlers seeking their fortune in cotton; the productivity and endurance of soils around the state varied drastically, and that variation in large part determined where the greatest wealth would accumulate and where the inevitable mansions would appear. The last significant block of land to be developed, the Yazoo-Mississippi Delta, was the most fertile in the South, and if civil war had been averted or delayed for a few more years, the unequalled abundance of its cotton fields would have undoubtedly financed many a grand house. But the time involved in draining the swamps and clearing the primeval forests of the Delta left precious few productive planting seasons during the antebellum period, and the postwar decade found more than one plantation lying fallow.

The hardships and disease associated with early settlement in the Delta discouraged all but the most stalwart and ambitious pioneers from attempting life there. Even those who braved the swamps, mosquitoes and wildlife were reluctant to subject their families to such dangers. If they did bring their families to Mississippi, they often built their fine houses in one of the hill communities overlooking the eastern edge of the Delta. Yazoo City, Lexington, Charleston and Carrollton all sheltered the families of early Delta planters; towns such as Greenwood, Clarksdale and Indianola, deep in the flatlands, date back to the 1830s but boast few if any homes of antebellum vintage. A few true Greek Revival mansions were built on plantations around the Delta, including the Burrus House at Benoit, Hollywood at Inverness and Perthshire in Bolivar County, but they were the exception to the rule.

One architecturally significant community that did develop in the pre–Civil War Delta was a cluster of elegant homes around LAKE WASHINGTON and LAKE LEE built by settlers from Kentucky and the Carolinas. These pioneer families floated down the Mississippi River as early as the 1820s, landing in the vicinity of Greenville and remaining to establish Glen Allen, Chatham and Leota Landing in Washington County. Their only connection with the outside world was the river, so they intermarried and developed a social hierarchy of their own. Supported by the astonishingly fertile soil of the Delta, prosperity was not long in coming:

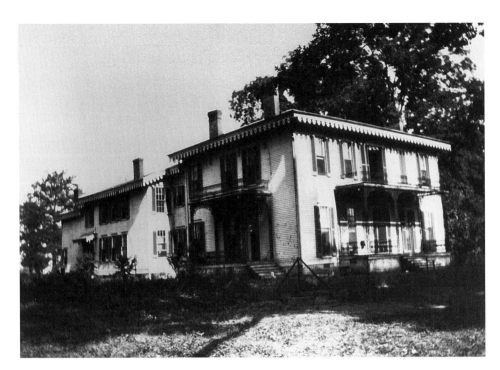

Wayside, on Lake Washington, home of one of the pioneering Worthington brothers. Photo courtesy of Russell Hall.

There were many beautiful homes and nearly all houses were built with the view of entertaining on a large scale. My father's house at Wayside cost him, with the furniture, thirty-five thousand dollars, and the chandeliers some three thousand more. . . . Solid mahogany and rosewood furniture was used generally; I never saw any veneered furniture before the war in the planters' houses. There were pianos in every home, and accomplished musicians and well trained voices were by no means rare. . . . My uncle, Elisha Worthington, had the largest and finest collection of Camellia Japonicas, then a rare flower under glass, in the United States; he also had a five thousand volume library. . . . There were graduates from the University of Virginia, the University of Mississippi and several of the more northern universities and a few from Heidelberg and Bonn, Germany.[1]

These are the reminiscences of one of the Worthingtons, the son of one of three brothers (William, Isaac and Samuel) who settled the lands in Washington County in the 1830s; another brother owned thousands of acres across the Mississippi River in Arkansas. All three Mississippi Worthingtons eventually built fine homes; William Worthington's Belmont is the only one remaining. Isaac's LEOTA collapsed into the Mississippi in the 1880s (a surprisingly common fate) and Samuel's WAYSIDE was condemned for demolition by the levee board in the 1930s. Wayside was Samuel Worthington's center of operations for his four vast plantations; the land around Wayside alone totalled four thousand acres. The house, built entirely of readily available cypress lumber, had at least twenty-one rooms. Travellers to the frontier Delta remembered the hospitality shown at this house, and the double wedding of the Worthington daughters, Mamie and Amanda, was the talk of the Delta for years.

Civil war struck hard in Washington County and at Wayside. Samuel Worthington remembered the encounter with Union troops:

There must have been at least ten thousand men on this expedition for their camps were scattered all over my father's Wayside, Redleaf and Mosswood plantations; they wrought fearful havoc during this month; they carried off all the mules and horses and ate a thousand head of cattle and a thousand head of hogs. . . . [The] cotton, some twenty-six thousand bales, was taken to Memphis, Tennessee, and auctioned off at fifty cents a pound. . . . Our next experience was with Admiral Sampson, then Captain Sampson. I never did know what brought him up in Lake Lee to Wayside. When the gunboat anchored, Captain Sampson . . . came with his officers all in dress uniform to my father's house at Wayside; they seemed to be paying a social call; I recollect one of the officers sat down to the piano and played Von Webber's last waltz. Among other things, Sampson said that he regretted to have been obliged to burn Greenville, but some indiscreet persons had fired into his portholes; he said he had shelled the town once or twice for the same offense, but it seemed to have no effect. . . . Captain Sampson's officers could not resist the temptation to carry off a few souvenirs. I suppose they eased their conscience by calling the articles taken by that name. . . . The officers wandered all over the house and grounds, for my father's house was good to look at those days, as were also the grounds, though the usual smart appearance of the grounds had been seriously injured by frequent raids. . . . In 1863, the Fourth Illinois Cavalry raided Washington County every week. On one of these raids, my brother, Albert D. Worthington, was killed by them. . . . He was at home at Wayside on furlough for a few days. He had just gotten into the house when the negro servant came rushing in to say, "The Yankees are coming." . . . My brother ran into the pasture back of the house [and] might have escaped, but a pack of hounds belonging to us, and with which he had been hunting, took his trail in full cry. This of course led to his discovery and one of the Yankees, being somewhat in advance of the others, shot him with a Sharps rifle.[2]

After the war, Wayside was rented out to various tenants and farm managers, and it stayed in respectable condition until well into the twentieth century. The daughter of a farm manager recalled her first impressions of the house in 1913:

My father came down to manage Wayside plantation. It was owned by an insurance company at Anchorage, Kentucky and they hired him to come and put it in shape for sale. . . . We came to Wayside and there were no lights, no water, no nothing but a big mansion. This house consisted of thirty-eight rooms with three stairways and it was in very good condition. It was really a show place. It was built before the Civil War and it was never completely finished. Mr. Worthington built the house and they had ordered mantels from France for the house and they never did arrive. . . . The house was a frame house with two ells in the back with a courtyard between. . . . There was a cistern in the middle of the courtyard where we got water to drink and to wash with. . . . The front gallery upstairs and down was trimmed with iron grill, vine and grape design, very much like the homes in New Orleans, and the back galleries had wooden railings up and downstairs, all around the Court. [Wayside] faced the river and in the front yard there were two mounds . . . later on the levee took the house, the mounds and everything and I never did know what happened. We had trees—the yard was a forest, with magnolia trees in the front yard, and we also had

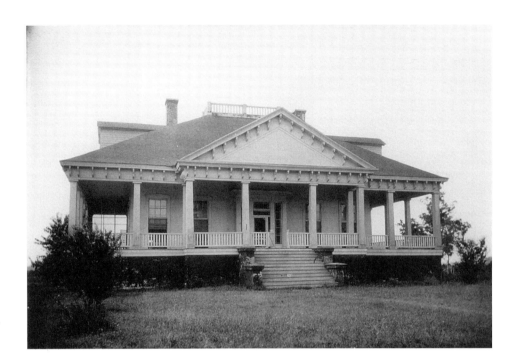

Swiftwater, named for the floods that rose to its foundation piers in 1858. Photo courtesy of MDAH.

a croquet place and . . . a tennis court in the front yard. Right across from it was the other Worthington house—"Belmont," and a Mr. W. W. Worthington lived there . . . "Mr. Will," as we called him, was really a southern gentleman. He wore white linen suits and panama hats and on hot days he carried a parasol, or umbrella, and he was a very genteel person.[3]

When new levee construction was planned following the disastrous floods of 1927, Wayside was situated on the wrong side of the proposed earthworks. It was condemned and demolished soon afterwards. Only Belmont, on Highway 1 south of Greenville, remains to memorialize the pioneering Worthington brothers.

Wayside and Leota were not the only Washington County houses to be taken by the river. Two other homes, gone long before cameras reached the Delta, also lost their battles with the Father of Waters. ALDOMAR, built by Alexander Flournoy in 1850, was, by description, a mirror image of Mt. Holly, the Delta's finest existing Italianate house. Aldomar had two foundations laid, each abandoned after neighbors told Flournoy that they were either too close or too far from the river. In exasperation, he turned the placement of the house over to his helpful friends, and Aldomar was finally built on the third foundation. All this advice didn't prevent the river from creeping closer and closer to Aldomar, lapping up to its doorstep before abandonment became inevitable. The owners gave up in 1890, tearing the house down to salvage its fine architectural elements.

Another home lost in time is described only as "the Georgian-Palladian mansion near Princeton [the first county seat of Washington County] that had already cost Junius Ward $30,000 when it fell into the river in 1855."[4] No further description survives; one can only imagine how fine a house of this value would have been, and wonder at the folly of building it so close to the altogether unpredictable Mississippi River.

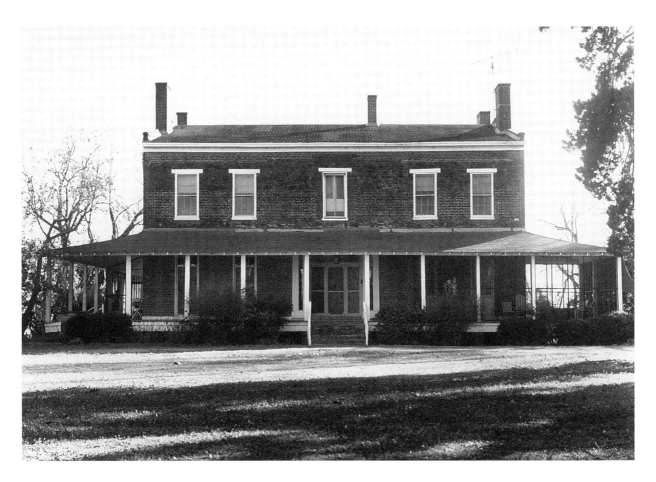

SWIFTWATER took its name from the floodwaters that swirled under its foundation piers in 1858, the year "when the levees were broken from one end of this county to the other and nearly the whole county overflowed."[5] It had been built in 1850 by Alexander Montgomery, a man with enough foresight to place his house on brick piers and far away from the river. Its single story was almost totally encircled by deep porches, their ceilings painted a cool blue. A full pediment was centered on the front of the house, with its dentiled cornice extending around the entire house. All woodwork, inside and out, was cedar, and two long rows of cedar trees led from the main road to the house.

During the Civil War, Mrs. Ann Finlay, wife of Washington County's first druggist, gathered up her children and the remaining supplies in her husband's store and fled the burning Greenville. She was forced to give up some of her medical supplies while fleeing south, but she reached the relative safety of Swiftwater. A makeshift drug store was set up in the house, serving the Lake Washington area through chaotic times. Long after Alexander Montgomery had sold Swiftwater, it would again serve as a medical refuge, this time during the yellow fever epidemic of 1878.

Swiftwater was still standing, apparently inhabited and in good condition, when WPA photographers toured the Delta in the 1930s. By the 1960s it was abandoned and sagging, and fire claimed it in May 1962.

Everhope, one of the earliest homes built in the Glen Allen area. Photo courtesy of MDAH.

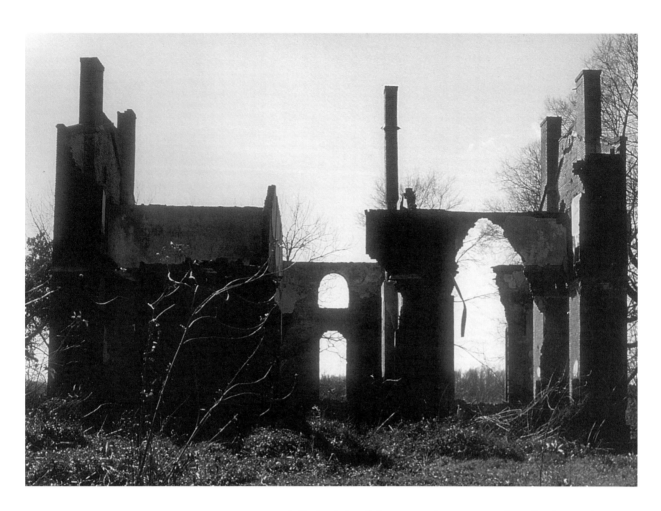

Everhope, with only its walls remaining after a 1992 fire. Photo by the author.

EVERHOPE, a solidly built brick house on the western edge of Lake Washington, was originally the home of Andrew Knox. Its simple exterior was complemented by parapeted chimneys on either gable end, and a shed-roof front porch was added sometime after the original construction date in the 1830s. Inside, a gracefully curved stair followed the walls of the front foyer, and four rooms on each floor opened off the central halls.

One of the Delta's most enduring folktales involves Everhope and Andrew Knox. Legend tells that when Knox built the house, he sealed several bottles of wine into the walls in anticipation of his son's wedding. The boy, only a small child at the time, died before reaching adulthood, so the wedding never took place. But each year at Christmas, the hidden bottles would materialize through the walls and pour their contents into glasses held by phantom hands. After this spectral celebration, the bottles would again disappear behind the walls. If the wine bottles ever actually existed, they were lost along with the rest of Everhope in a fire that broke out, ironically, at Christmas in 1992.

APPENDIX: MORE LOST MANSIONS

Following is a list of houses I have found mentioned in various sources. Some are well known but excluded from this book because of space limitations. Others seem to have evaporated completely into the mists of history; even the most knowledgeable local historians have no memory of them. Perhaps a few still exist and are now known by another name. Should this book inspire questions about an old family photo or stir the dust on greatgrandmother's diary of plantation life, perhaps these houses can be documented as well. Any such material or information may be directed to the author c/o University Press of Mississippi, 3825 Ridgewood Road, Jackson, Mississippi 39211-6492

Adams County

Belmont
Corey House
Courtland
Etania
Glenwood
The Hermitage
Kenilworth
Laurel Hill
Llangoland
Magnolia
Montebello
Peachland
Sligo
Soldier's Retreat
Sunnyside
Treenwood
Woodland

Benton County

Gothic Hall

Bolivar County

Perthshire

Carroll County

Briarwood

Claiborne County

The Ark
Ashland
Belmont
Glensade
Greenwood
Hopewell
Oaklawn
The Oaks
Pierremont
White Hall

DeSoto County
Colonel T. W. White House

Franklin County
Abner Kinnison House

Grenada County
Glenwild
John Cratin Stokes House

Harrison County
Dorothy Dix House
Hand Houses (2)
Haunted House

Hinds County
Mt. Herman (Dickey Institute)
Shadowlawn

Holmes County
Eggleston House
Rev. W. W. Holman House
Terrystone

Jefferson County
Arundo
Auburn Hall
Dent's Folly
Everton
Gayoso
Home Hill
Moss Hill
Mt. Airy
Oakwood
The Pines
Villa Gayoso
Woodburn

Kemper County
Giles Plantation

Lafayette County
Carter/Tate House

Rowland House
Shipp House
Jacob Thompson House

Lowndes County
Belmont
Cravin/Dickenson House
Lindamood
McBee House
O'Neal/ Beard House
Puckett House

Madison County
Bellevue
Harvey Plantation

Marshall County
Athenia
Cloverland
Hazelwood
The Homestead
Malone House
McAlexander House
Strickland Place
Suavatooky
Thompson's Folly

Monroe County
Anderson House
Carlisle/Gunn House
Dalton/Brandon/Mattox House
Myrtle Bower
Roy Jones House
Suristan

Noxubee County
Governor Clark House

Panola County
Estes House
Henry Laird House
William David Sledge House
James Monroe Wallace House

Pontotoc County
Stony Lonesome

Sunflower County
Hollywood

Tippah County
Brougher House

Warren County
Messenger House
Willis House

Washington County
Locust
Three Oaks
Wildwood

Wilkinson County
Ashwood
Walnut Grove

Yazoo County
Bleak House

NOTES

INTRODUCTION

1. *Mississippi: The WPA Guide to the Magnolia State* (1938; reprint, with an introduction by Robert S. McElvaine, Jackson: University Press of Mississippi, 1988).

2. Ibid.

CHAPTER 1

1. Harnett T. Kane, *Natchez* (New York: William Morrow & Company, 1947), 41.

2. Alexander Wilson, as quoted in Alma Carpenter, "A Note on the History of The Forest Plantation, Natchez," *Journal of Mississippi History* 45 (1983): 130–37.

3. Eliza Allen Starr, as quoted in Carpenter.

4. Dr. John C. Jenkins, as quoted in Carpenter.

5. Joseph Holt Ingraham, *The Southwest by a Yankee* (New York 1835), as quoted in Samuel Wilson, Jr., "Clifton—An Ill-Fated Natchez Mansion," *Journal of Mississippi History* 27 (1965): 179–89.

6. Colonel Thomas Kilby Smith, as quoted in Wilson.

7. Maria Sessions, as quoted in Catharine Van Court, *The Old House* (Richmond: The Dietz Press, 1950), 25–29.

8. Steve Power, "The Memento—Old and New Natchez—1790–1897," as quoted in Wilson, 187.

9. Kane, *Natchez*, 135–36.

10. Catharine Van Court, *In Old Natchez* (New York: Doubleday, 1937), 93.

CHAPTER 2

1. Stark Young, *So Red the Rose* (New York: Charles Scribner's Sons, 1934).

CHAPTER 3

1. Katy M. Headley, *Claiborne County, Mississippi: The Promised Land* (Port Gibson, Miss.: Claiborne County Historical Society, 1976).

2. Alfred T. Bogen, Jr., "A Brief History of Anchuca Plantation" (manuscript in "Anchuka" file, Mississippi Department of Archives and History Library, 1988).

3. *The Southern Reveille* (Port Gibson, Miss.), February 21, 1890.

CHAPTER 4

1. Mrs. N. D. Deupree, "Historic Homes of Mississippi," *Publications of the Mississippi Historical Society* 6 (1902): 245–64.

2. Edward R. Welles, unpublished manuscript dated March 29, 1856.

3. Varina Howell Davis, as quoted in Frank E. Everett, Jr., *Brierfield: Plantation Home of Jefferson Davis* (Jackson: University Press of Mississippi, 1971).

CHAPTER 5

1. Mrs. N. D. Deupree, "Historic Homes of Mississippi," *Publications of the Mississippi Historical Society* 6 (1902): 245–64.

2. Pseudonymous "X and Y," as quoted in Shirley Faucette, "Clinton—Yesterday," *Journal of Mississippi History* 40 (August 1978): 215–30.

3. Deupree, op. cit.

4. Elizabeth Hatheway, as quoted in Hugh Miller Thompson II, *The Johnstones of Annandale* (self-published, 1992).

5. Thompson: 22–24.

6. Ibid.

CHAPTER 6

1. Stark Young, *The Pavilion* (New York: Charles Scribner's Sons, 1951).

2. Lucie Magee, "Vaiden: A Romantic Past and A Promising Spot for Industry," *Jackson Daily News,* April 30, 1950.

CHAPTER 7

1. *Mississippi: The WPA Guide to the Magnolia State* (1938; reprint, with an introduction by Robert S. McElvaine, Jackson: University Press of Mississippi, 1988).

2. Martha Neville Lumpkin, *Minor, Scales, Cottrell and Gray Families of Virginia, North Carolina and Mississippi*, n.p., n.d.

CHAPTER 8

1. Jane Isbell Haynes, *William Faulkner: His Tippah County Heritage* (Columbia: Seajay Press, 1985).

2. Ibid.

CHAPTER 9

1. Robert Ivy and Frances Ivy, *A Boy's Will: A Mississippi Memoir* (Aberdeen: Allmond Printing Company, 1991).

2. Ibid.

CHAPTER 12

1. Samuel Worthington, as quoted in *Papers of the Washington County Historical Society*, 1912, 284.

2. Ibid.

3. Mary Howey Key, interview by Roberta Miller, Mississippi Department of Archives and History and the Washington County Library System Oral History Project (October 1977).

4. Worthington, *Papers of the Washington County Historical Society.*

5. Ibid.

BIBLIOGRAPHY

Bailey, Robert J., and Priscilla M. Lowrey, eds. *Historic Preservation in Mississippi: A Comprehensive Plan.* Jackson: Mississippi Department of Archives and History, 1975.

Bettersworth, John K. *Confederate Mississippi.* Philadelphia: Porcupine Press, 1978.

___. "The Reawakening of Society and Cultural Life." Chap. 21 in *A History of Mississippi,* edited by Richard A. McLemore. Jackson: University Press of Mississippi, 1973.

Bogen, Alfred T., Jr. "A Brief History of Anchuca Plantation." Mississippi Department of Archives and History, Jackson, 1988. Photocopy.

Brinson, Carroll. *Jackson: A Special Kind of Place.* Jackson, 1977.

Brough, Charles Hillman. "Historic Clinton." *Publications of the Mississippi Historical Society* 7 (1903): 281–304.

Campbell, Mary H. "Moss House." Mississippi Department of Archives and History, Jackson, 1940. Photocopy.

Carpenter, Alma. "A Note on the History of the Forest Plantation, Natchez." *Journal of Mississippi History* 46 (1984): 130–37.

Cheatham, Edgar J., Jr. "Washington County, Mississippi: Its Antebellum Generation." Master's thesis, Tulane University, 1950.

Claiborne, J. F. H. *Mississippi as a Province, Territory and State.* 1880. Reprint, Baton Rouge: LSU Press, 1964.

Conway, Sigrid A. *Shrines to Yesterday.* N.p., n.d.

Cooper, J. Wesley. *Antebellum Houses of Natchez.* Natchez: Southern Historical Publications, Inc., 1970.

Coppock, Paul R. "A Boy Who Rallied Round the Flag." *Memphis Commercial Appeal,* September 1982.

Cotton, Gordon. "The Ghost of Hyland House." *Vicksburg Sunday Post,* 22 April 1973.

___. "History Abounds Atop Downtown Vicksburg's Castle Hill." *Vicksburg Sunday Post,* 27 March 1994.

Criss, Leslie. "1863 Drawing Shows Windsor Before Fire." *Vicksburg Evening Post,* 7 August 1992.

Crocker, Mary Wallace. *Historic Architecture in Mississippi.* Jackson: University Press of Mississippi, 1973.

Daigre, Barbara A. *The History of Grenada County.* Mission: Inter-Collegiate Press, 1985.

Davis, Edwin Adams, and William Ransom Hogan. *The Barber of Natchez.* Baton Rouge: LSU Press, 1973.

DeRosier, Arthur H., Jr. "Carpenter's Estimate on the Building of 'The Forest.'" *Journal of Mississippi History* 27 (August 1965): 259–64.

Deupree, Mrs. N. D. "Historic Homes of Mississippi." *Publications of the Mississippi Historical Society* 6 (1902): 245–64.

Douglas, Ed Polk. *Architecture in Claiborne County, Mississippi.* Jackson: Mississippi Department of Archives and History, 1974.

Everett, Frank E., Jr. *Brierfield: Plantation Home of Jefferson Davis.* Jackson: University Press of Mississippi, 1971.

Harrell, Virginia C. *Vicksburg and the River.* Vicksburg: Harrell Publications, 1986.

Harris, William C. "Reconstruction of the Commonwealth." Chap. 18 in *A History of Mississippi*, edited by Richard A. McLemore. Jackson: University Press of Mississippi, 1973.

Haynes, Jane Isbell. *William Faulkner: His Lafayette County Heritage.* Columbia: Seajay Society, 1992.

_____. *William Faulkner: His Tippah County Heritage.* Columbia: Seajay Society, 1992.

Haynes, Robert V. "The Formation of the Territory." Chap. 8 in *A History of Mississippi,* edited by Richard A. McLemore. Jackson: University Press of Mississippi, 1973.

Headley, Katy M. *Claiborne County, Mississippi: The Promised Land.* Port Gibson: Claiborne County Historical Society, 1976.

Hermann, Janet S. *Joseph E. Davis, Pioneer Patriarch.* Jackson: University Press of Mississippi, 1990.

Howell, Elmo. *Mississippi Home-Places.* N.p., n.d.

_____. *Mississippi Scenes.* N.p., n.d.

Howie, Bob. "Ruins of Windsor Given to State." *Jackson Clarion-Ledger,* 12 May 1974.

Faucette, Shirley. "Clinton—Yesterday." *Journal of Mississippi History* 40 (August): 215–30.

Ivy, Robert, and Frances Ivy. *A Boy's Will: A Mississippi Memoir.* Aberdeen: Allmond Printing Company, 1991.

James, D. Clayton. *Antebellum Natchez.* 1968. Reprint, Baton Rouge: LSU Press, 1993.

Jordan, Winthrop D. *Tumult and Silence at Second Creek.* Baton Rouge: LSU Press, 1993.

Kane, Harnett T. *Natchez on the Mississippi.* New York: William Morrow and Company, 1947.

Kaye, Samuel H., Rufus Ward, Jr., and Carolyn B. Neault. *By the Flow of the Inland River.* N.p., n.d.

Key, Mary Howey. Interview by Roberta Miller. Washington County Library System Oral History Project, 1977.

Lane, Mills. *Architecture of the Old South: Mississippi/Alabama.* New York: Abbeville Press, 1989.

Logan, Marie T. *Misssissippi-Louisiana Border Country.* Baton Rouge: Claitor Publishing, 1980.

Lumpkin, Martha Neville. *The Lumpkin Family of Virginia, Georgia and Mississippi.* N.p., 1973.

Magee, Lucie. "Vaiden . . . A Romantic Past and A Promising Spot for Industry." *Jackson Daily News,* 30 April 1950.

Mayhall, Louise. "Plantation Beauty Survives at 124-Year Old Everhope." *Memphis Commercial Appeal,* 18 July 1956.

McAlexander, Hubert H. "Flush Times in Holly Springs." *Journal of Mississippi History* 48 (February 1986): 1–13.

_____. "Pointer Family Important Part of Holly Springs' Past." *Holly Springs (Mississippi) South Reporter*, 14 October 1982.

McAlester, Virginia, and Lee McAlester. *A Field Guide to American Houses.* New York: Alfred A. Knopf, 1986.

McCain, William D., and Charlotte Capers, eds. *Papers of the Washington County Historical Society: Memoirs of Henry Tillinghast Ireys.* Jackson: Mississippi Historical Society, 1954

McIntosh, James T. *The Papers of Jefferson Davis.* Vol. 1. Baton Rouge: LSU Press, 1974.

Mead, Carol Lynn. *The Land Between Two Rivers.* Canton: Friends of the Madison County Public Library, 1987.

Miller, Mary Warren, Ronald W. Miller, and David King Gleason. *The Great Houses of Natchez.* Jackson: University Press of Mississippi, 1986.

Miner, Ward L. *The World of William Faulkner.* New York: Pageant Book Company, 1959.

Moore, Glover. "Separation from the Union, 1854-1861." Chap. 15 in *A History of Mississippi,* edited by Richard A. McLemore. Jackson: University Press of Mississippi, 1973.

Moore, John Hebron. "Colonel John Hebron of LaGrange Plantation (1802–1862)." Vicksburg, Mississippi, Old Courthouse Museum. Photocopy.

_____. *The Emergence of the Cotton Kingdom in the Old Southwest.* Baton Rouge: LSU Press, 1988

Nathan, Kathy. "Fragment of History Razed Along with Historic Gattman House." *Aberdeen (Mississippi) Examiner*, 19 April 1984.

Ogden, Florence Sillers. "Claiborne Home Now Available for State Maintenance and Support." *Jackson Clarion-Ledger,* 1 February 1960.

Oliver, Nola Nance. *The Gulf Coast of Mississippi.* New York: Hastings House, 1941.

_____. *Natchez: Symbol of the Old South.* New York: Hastings House, 1940.

Paddleford, Clementine. "Tea Time in the South." *Memphis Commercial Appeal,* 9 May 1954.

Perrin, James Morris. *Reverend Newit Vick, Founder of Vicksburg, Mississippi.* N.P., 1990.

Polk, Noel, ed. *Natchez Before 1830.* Jackson: University Press of Mississippi, 1989.

P'Pool, Kenneth H. "The Architectural History of a Mississippi Town 1817-1866." 1990.

Rather, Hugh H. "Seven Drawings Researched and Made by Hugh Rather, Architect of Holly Springs, Mississippi, to Record the Remains of the Two Homes of the Lumpkin Family in Marshall County, Mississippi." 1979.

Ray, Florence Rebecca. *Chieftain Greenwood Leflore and the Choctaw Indians of the Mississippi Valley.* Memphis: C. A. Davis Printing Company, 1976.

Rifkind, Carole. *A Field Guide to American Architecture.* New York: New American Library, 1980.

Riley, Franklin L. "Extinct Towns and Villages of Mississippi." *Publications of the Mississippi Historical Society* 5 (1902): 348–50.

Rowland, Dunbar. *Mississippi.* 2 vols. 1907. Spartanburg: The Reprint Company, 1976.

Sansing, David G., Sim C. Callon, and Carolyn Vance Smith. *Natchez: An Illustrated History.* Natchez: Plantation Publishing Company, 1992.

Scarborough, William K. "Heartland of the Cotton Kingdom." Chap. 12 in *A History of Mississippi,* edited by Richard A. McLemore. Jackson: University Press of Mississippi, 1973.

Shurden, Irene. "A History of Washington County, Mississippi, to 1900." Master's thesis, Mississippi College, 1963.

Smith, Frank E. *The Yazoo River.* 1954. Reprint, Jackson: University Press of Mississippi, 1988.

Smith, J. Frazer. *White Pillars: The Architecture of the South.* New York: Bramhall House, 1941.

Snell, Susan. *Phil Stone of Oxford: A Vicarious Life.* Athens: The University of Georgia Press, 1991.

Sobotka, John C. *A History of Lafayette County, Mississippi.* Oxford: Rebel Press, 1976.

Sutton, Cantney V. *History of Art in Mississippi.* Gulfport: The Dixie Press, 1929.

Taylor, Herman E. *Faulkner's Oxford: Recollections and Reflections.* Nashville: Rutledge Hill Press, 1990.

Thompson, Hugh Miller II. *The Johnstones of Annandale.* N.p., 1992.

Vaiden Garden Club. "Vaiden Heritage." Photocopy, 1976.

Van Court, Catharine. *The Old House.* Richmond: The Dietz Press, 1950

Wells, Marion Rogers. "Clinton: Building on Yesteryear, Planning for Tomorrow." Photocopy, 1984.

Williams, James H. "Jean Lafitte's Pirate House Closed to Public at Waveland." *Jackson Clarion-Ledger,* 28 November 1965.

Williamson, Joel. *William Faulkner and Southern History.* New York: Oxford University Press, 1993.

Wilson, Jack Case. *Faulkners, Fortunes and Flames.* Nashville: Annandale Press, 1984.

Wilson, Samuel, Jr. "Clifton: An Ill-fated Natchez Mansion." *Journal of Mississippi History* 46 (1984): 179–89.

Works Progress Administration. *Mississippi: The WPA Guide to the Magnolia State.* 1938. Reprint, Jackson: University Press of Mississippi, 1988.

Young, Stark. *The Pavilion.* New York: Charles Scribner's Sons, 1951.

_____. *So Red the Rose.* New York: Charles Scribner's Sons, 1934.

INDEX

A

Aberdeen: founded by Robert Gordon, 83; incorporated 1837, 83; named county seat 1849, 83; early growth and culture, 83

Airliewood: mentioned, xii

Aldomar: mirror image of Mt. Holly, 100; lost to river, 100

Anchuka: construction in 1835, 24; description of site, 24; description of interior, 24; "shower bath," 24; slave quarters, 24; decline and abandonment, 24; description in 1927, 24; demolition, 25

Anderson, Carl Otto: alterations to Gattman House, 86; scrollwork on Lambeth-Milligan House, 86

Annandale: mentioned, xii; construction begins, 52; description, 52-53; during Civil War, 54; sold out of Johnstone family, 55; destroyed by fire, 55

Archer, Richard: development of two agricultural empires, 23-24; builds Anchuka, 24

Auburn: as example of Federal style, xi

Audubon, John James: painting of Natchez in 1822, 10

Avant-Stone House: built as "Bride's House," 57; description, 57; Federal occupation, 58; sold to Edward Mayes, 58; sold to James Stone, 58; storage for unsold Faulkner works, 58; destroyed by fire, 58

Avant, Tomlin: immigration to Oxford, 57; builds "Bride's House," 57; declares bankruptcy, 58; dies in debt, 58

B

Balfour, Catherine: receives Homewood as wedding present, 15

Beauliau. *See* Dixie White House

Belmont: built by William Worthington, 98

Benjamin, Asher, xii

Bethlehem Academy. *See* Pointer House

Bowling Green: conjectural description, 17; burned by Federal troops, 17; described by Stark Young, 18; second home on site, 19; columns remaining, 19

Bradford, General Benjamin: origin of wealth, 88; builds Bradford house, 88; loses house in business failure, 88

Bradford House: built by General Bradford, 88; description, 88; loss of right wing, 88; abandonment and demolition, 88

Brierfield: built by Jefferson Davis, 41; description, 41-42; outbuildings and grounds, 42; ransacked in Civil War, 43; sold to former slaves, 43; returned to Jefferson Davis, 43; Jefferson's last visit, 43; deterioration, 43; destroyed by fire, 43

Brown, Andrew: arrival in Natchez, 12; partnership with Peter Little, 12; designs Natchez landmarks, 12; purchase of sawmill, 13; first house destroyed by tornado, 13; builds Magnolia Vale, 13

Brown's Gardens: description, 13

Burr, Aaron: arrest in Natchez, 5; flees before trial, 7

Burwell, Armistead: as owner of Castle, 36; Unionist sentiment, 36

C

Caldwell, Elizabeth Robinson: marriage to Judge Caldwell, 46; inherits Caldwell mansion, 47; murdered by Judge Kearney, 47

Caldwell, Isaac: chosen Circuit Judge, 46; killed in duel, 47

Caldwell-Moss House: description, 46; deterioration and demolition, 47

Castle, the: description, 35; occupation during Civil War, 36; destruction by Federal troops, 36

Cayce House: as example of Columbus Eclectic Style, 89

Cedarhurst: mentioned, xii

Claiborne House: built as Laurelwood, 92; description, 92; condition in 1969, 93; demolition, 93

Claiborne, J.F.H.: distinguished family, 92; political and literary career, 92; buys Laurelwood, 92; writes first history of Mississippi, 92; manuscript lost, 93; death, 93

Clifton: built in 1821, 10; sale to Anne Linton, 10; effects of 1840 tornado, 10; destroyed in Civil War, 11-12

Clinton: as new state's center of education, 45; name changed from Mt. Salus, 46

Columbus: early development, 89

Columbus Eclectic Style: mentioned, xii; elements of style, 89; Flynnwood, 89; Cayce House, 89; surviving examples, 90

Como: develops along railroad, 58

Concord: design description, xi, 3; 1820s additions, 3; abandonment, 5; destroyed by fire, 5

Cox, William Henry: sends sons to Mississippi, 69

Cox, William Henry, Jr.: builds model plantation at Galena, 69

D

Dandridge, Ann McGehee: receives Hollywood as wedding present, 59; journey to Shiloh, 59

Daniell, Smith: builds Windsor, 27; extent of plantation system, 27; death, 27

Davis, Jefferson: mentioned, 36; decision to build at Davis Bend, 40; death of first wife, 40; political career, 41; builds Brierfield, 41; elected President of Confederacy, 42; honored at Shamrock, 38

Davis, Joseph Emory: mentioned, 35; life at Shamrock, 38; establishes plantation at Davis Bend, 40; legal/political career, 40; destruction of first house, 40; builds Hurricane, 40

Davis, Varina Howell: describes building of Brierfield, 41

Delta: early settlements, 97

D'Evereaux: mentioned, xii

Dixie White House: built as Beauliau, 95; visited by President Wilson, 95; conversion into nursing home, 96; damage from Hurricane Camille, 96

Donahue: relationship with Jean Lafitte, 91; builds Pirate House, 91

Dortch, Bessie Griffin: inherits

restored to Britton family, 55; destroyed
by fire, 55

Ingraham, Joseph Holt: description of
Natchez bluffs, 10

Italianate style: elements of style, xii;
examples of style, xii

J

Jackson: as new state's seat of government,
45; chosen as capital city, 48; city plan
laid out by Peter Van Dorn, 48; residen-
tial development along North State
Street, 48

Johnson, Joseph: builds The Grove, 21

Johnstone, Helen: as "bride of Annandale,"
53; engagement to Henry Vick, 53; mar-
riage to George C. Harris, 55

Johnstone, John: buys land in Madison
County, 50; builds first house at
Annandale, 50; death in 1848, 51

Johnstone, Margaret: builds Chapel of
the Cross, 51; chooses Minard Lafever
plan for new Annandale, 51; death, 55

Jones and McIlwaine Foundry: role in
growth of Holly Springs, 67

K

Kelly, George Malin Davis: inherits four
Natchez mansions, 5

Kirkwood: home of Governor William
McWillie, 45; description, 45

Knox, Andrew: builds Everhope, 102

L

Lafever, Minard: as author of *Beauty of
Modern Architecture*, xii

LaGrange (Bovina): description, 38;
drawing in Hinkle-Guild Catalogue,
38-39; occupation by Federal troops,
38; abandonment and demolition, 38

LaGrange (Woodville): original structure, 19;
remodeled by Samuel Sloan, 19; similari-

ties to Longwood, 19; destroyed by fire,
19; remaining columns, 21

Lambeth-Milligan House: description,
86; Carl Otto Anderson scrollwork, 86;
destroyed by fire, 88

Lane, John: implements father-in-law's
town plan of Vicksburg, 33

Larmour, Jacob: commissioned to build
Annandale, 51

Laurel Hill: built by Rush Nutt, 30;
description, 31; floor plan, 31;
dismantled, 31

Laurelwood. *See* Claiborne House

Laws Hill community: site of Hickory
Park, 68

Lea, Addison: builds Griffin-Dortch
House, 85

Leake, Walter: builds home at Mt. Salus, 45

Learned, Andrew Brown: builds home to
replace Magnolia Vale, 14

Learned, Rufus: inherits Magnolia Vale, 13;
expansion of family business, 13

Leflore, Greenwood: commissions James
Clark Harris to build Malmaison, 64;
Choctaw heritage, 64; education in
Nashville, 64; elected Choctaw chief, 64;
signs Treaty of Dancing Rabbit Creek,
64; receives nucleus of plantation empire,
64; builds first home at Teoc, 64; Union
sympathizer, 66; death, 66

Lochinvar: mentioned, 83

Longwood: abandoned by workers, xiii;
similarities to LaGrange, 19; mentioned,
31; comparison to Morro Castle, 73

Lumpkin, William Blanton: moves to Holly
Springs, 73; construction of mill, 73;
begins work on Morro Castle, 73; lives
until 1877 in unfinished house, 73

M

Magnolias: mentioned, xii, 83

Magnolia Vale: location beneath bluffs,

13; description by Harnett Kane, 13; endangered by erosion, 14; abandonment, 14; destroyed by fire, 14

Malmaison: mentioned, xii; built by Greenwood Leflore, 64; description, 64-66; object of arson attempts, 66; remaining in Leflore family, 66; destroyed by fire, 66; loss of outbuildings, 66

Mannsdale: development as an agricultural region, 45

Marshall, Charles Kimball: arrival in Mississippi, 33; reputation as a Methodist preacher, 33; builds Vick-Marshall House, 33

Mason, Eilbeck: buys The Castle in 1852, 36; relation to Robert E. Lee, 36

Maury Institute: founded by Elizabeth Watson, 71; becomes North Mississippi Presbyterian College, 71; becomes Mississippi Synodical College, 71; merger with Belhaven College, 71

Mayes, Edward: buys Avant-Stone House, 58; chancellor of University of Mississippi, 58

McGehee, Edward: political career, 17; owner of McGehee Mill, 17

McGehee Mill: destroyed in Civil War, 17

McNairy House: built 1847, 84; description, 84; used as boardinghouse, 84; incorporated into Clopton Hotel, 84; demolished, 84

Minor, Catherine Lintot: life at Concord, 4

Minor, Stephen: description of plantations, 4; purchase of Concord, 4; appointed governor of Natchez District, 4

Mississippi Synodical College. See Maury Institute

Montgomery, Alexander: builds Swiftwater, 101

Morro Castle: mentioned, xiii; intended to be largest house in North Mississippi, 73;

sandstone foundations, 73; work halted by Civil War, 73; abandonment and demolition, 73

Mount Holly: mentioned, xii

Mount Salus: home of Governor Walter Leake, 46

Mullin, Robert: arrival in Grenada, 61; builds Evergreen, 61; as leading citizen of Grenada, 61

N

Natchez: Federal style houses, xi; origin of pilgrimage, xiv; architectural development under Spanish control, 3

Norfleet Ruffin Sledge House: description, 59; destroyed by fire, 61

North Mississippi Presbyterian College. See Maury Institute

Nugent-Shands House: built by John Shaw, 48; description, 48; 1890s renovation, 48; demolished for commercial development, 48

Nutt, Haller: childhood at Laurel Hill, 31

Nutt, Rush: development of cotton seed, 5, 30; immigration to Mississippi, 30; adaptation of cotton gin to steam power, 30

O

Oakland: built by Peter Scales, 74; description, 74; demolition in late 1800s, 74

Oaks: description, 48

Osmun, Benijah: builds Windy Hill Manor, 5; offers sanctuary to Aaron Burr, 5; death, 7

Ossian Hall: built in 1848, 94; description, 94; restored with southern tearoom, 94; destroyed by fire, 94-95

Oxford: origins as trading post, 57;

chosen as site for university and
county courthouse, 57

exterior description, 27-28; floor plan description, 27-28; use by Confederate lookouts during Civil War, 28; sketch by Union soldier, 28; use as hospital, 28; destroyed by fire, 29; columns remaining, 29

Windy Hill Manor: description, 5; sold to Gerard Brandon, 7; alterations by Stanton family, 7; decline and deterioration, 7; described in 1941, 8; demolition, 8

Woodville: early development, 17; site of state's first railroad, 17

Works Progress Administration (WPA): description of houses between Red Banks and Memphis, xiii; documentation of houses, ix

Worthington family: early plantations in Delta, 98

Worthington, Samuel: builds Wayside, 98; owns four plantations, 98

WPA. *See* Works Progress Administration

Y

Yerger, George Shall: arrives in Mississippi, 48; builds Yerger House on North State Street, 49; death in hunting accident, 49

Yerger House: description, 48-49; grounds, 49; as nucleus of Deaf and Dumb Institute, 49; destroyed by fire, 49